Brahaus

Brahaus

Samuele Mazza

CHRONICLE BOOKS SAN FRANCISCO

First published in the United States in
1994 by Chronicle Books.
Copyright © 1992 Idea Books, Milano

Printed in Italy.

Caption Translation by Joe McClinton

Cover and text design by
Tom Morgan at Blue Design

Library of Congress Cataloging-in-
Publication Data.

Mazza, Samuele, 1960-
 [Reggi-secolo. English]
 Brahaus / Samuele Mazza
 p. cm.
 Translation of: Reggi-secolo.
 ISBN 0-8118-0593-X :
 1. Brassierres -- Exhibitions. I. Title.
TT677.M3913 1994
746.9'2--dc20 93-5515
 CIP

Distributed in Canada by Raincoast Books
112 East Third Avenue
Vancouver, B.C. V5T 1C8

10 9 8 7 6 5 4 3 2 1

Chronicle Books
275 Fifth Street
San Francisco, CA 94103

Contents

Foreword

I have always tried to bring my world, that of fashion, closer to the world of art, as has been done by some of my illustrious predecessors. Chanel, Max Jacob, Juan Gris and Cocteau have inspired my work along with Poiret, Picabia, Vlamink, Derain and Dufy and Schiaparelli, intimate friend of the surrealists. Yet the figure who, though he did not belong to fashion, influenced me perhaps more than any other, is Andy Warhol. His pop art launched the mythicization of the objects and images of consumer society. He made them works of art, leaving aside their meaning.

Upon this conceptual basis, I began a project of decontextualization of clothing and, above all, of the related accessories, such as the brassiere, the shoe, the tie, the t-shirt, the hat. I went beyond the limits of

the sector to seek the freedom for experimentation that painters, sculptors, architects, designers have always had. In fashion it is conditioned by materials, by sizes and by the market. Though there has been a structural break with haute couture, fashion is always tied to the imperative of immediate seduction and therefore to commercial logic. Brahaus is intended to be a message of profound change. Its path is not scattered with the extremist and destructive signs of deconstruction, but has been playfully conquered by a rapture for the new. These creations come about as part of a game, as do the best things, not conditioned by commercial rules. They are full of hints and free and personal references linked with the cultural backgrounds of

the artists involved. The basis of each of these is the intention to communicate a certain optimism and the great hope that exists in "memory," the paradise from which no one can ever drive us away.

I wish to thank Ken's Gallery, Walter Bellini, Giacomo Sanfilippo, Gianni Monini, Antonella Amapane, Laura Delli Colli, Anna Siccardi, Françoise Picoli, Simon Chalmers, Giuseppe di Somma, for their precious collaboration.

I dedicate this volume to women everywhere.

<div align="right">

Samuele Mazza

</div>

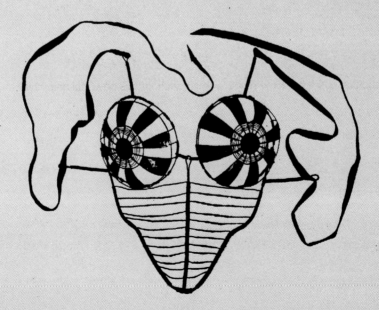

Introduction

Perhaps of all the garments invented by man or woman to improve their appearance—from the loincloth to the tunic, from the jockstrap to hats—the one that seems to go against nature, since it goes against the law of gravity, is the brassiere. Yet the bra is perhaps the first example of an authentic structural cosmetic. How many women, without this powerful help, this "support," would have lost their attraction too early? It is no use claiming that the recurrent anti-bra fashion demonstrates that it is no more than a superfluous supplement. One look at so many of today's topless bathers, and you realize that the percentage of the "tolerable" ones is minimal.

So, all our praise to those fashion designers and artists who have understood the bra's aesthetic as well as corrective importance.

Besides, you only need to leaf through this rich collection of models, collected and coordinated by Samuele Mazza to realize how it has indeed aroused the most incredible and imaginative creations in the artists. There are those which are still decidedly functional and only slightly embellished by additions or inclusions and those which are completely non-functional, which have used the form and transformed it into something else—a rigid breast plate, a sweet attraction, an ornament, a weapon. We have bras padded with candy and bristling with pins, real hanging gardens, and aerodynamic instruments.

It is the "semantic multiplicity" that is the most stimulating side to this collection. The brassiere is transformed into an object of desire but also of horror. It becomes medieval armour or erotic "sheath," mere decoration, or full-fledged clothing. From the classical courtly mosaics of Piazza Armerina to the more recent fashion of the bikini, the bra has been one of the items of clothing that has been changed from an intimate to an explicit, indeed exhibitionistic, garment. It is now an indispensable and irreplaceable complement for the present and future of women's clothing. It would be inappropriate, at this point, to make a serious analysis of this ironic and

bizarre collection. It would be too easy to consider as absurd those bras made out of materials that are totally alien to them (gloves, televisions, telephones) or which only dish up a linguistic pun ("World cup," "Robust," "Wooden chest"). Instead, I would like to point out how some of the more effective models are the ones using original materials and therefore a new type of design—the net, metallic cups, plastic ones, and so on. Indeed, in these cases, the decorative element is without a doubt the decisive complement to the function of the bra. But it is also true that an excess of ornamentation is often counter-productive, and may lead to annoyance and to kitsch.

Gillo Dorfles

Bra Design

This is intended to be a manifesto for the liberation of the brassiere. Liberation from an ordained role (that of orthopedic support), from a confined territory (the intimate), from a symbology which is mythicized (the "stacked" sex goddess) or condemned as evil (the bra as symbol of subordinate femininity).

Brahaus, the exhibition of two hundred of the over one thousand art and design brassieres collected by Samuele Mazza, introduces this object of passion and repulsion into the unbounded territory of creative energy. It is an energy that cannot bear stylistic cages and prefers to fly free, gathering like a queen bee, from flower to flower, the juicy pollen to feed herself. And by pollen, outside of the metaphor, I

mean the most disparate formal references, the most unthinkable allusions, the most candid and perverse symbologies. Since it is difficult to abandon the linguistic codes, I will talk of a design bra, though the term, albeit more than appropriate, runs the risk of being a bit of a tight fit. Sticking to the rigid, Bauhaus definition of "form follows function," the bra is fully entitled to be a design object, since it performs excellently the function of supporting. But the term is still a tight fit, if by design we mean only objects which are inert and inanimate, composed and prudent, rigorous and efficient. Perhaps *Brahaus* is a good opportunity to give the term a broader meaning and more vitality, to enable it to participate in the mechanisms of fascination

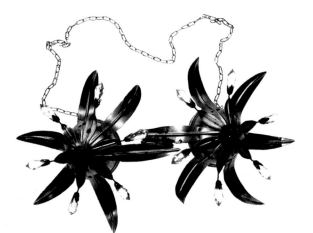

and seduction. It is high time, in fact, that objects were allowed to be seductive. Because, as Gilles Lipovetsky states, "the more seduction unfurls itself, the more awareness becomes realist; the more the lucid aspect prevails and the more the economic ethos is reestablished; the more the ephemeral wins through, the more democracies are stable" (*L'impero dell'effimero*, Garzanti, 1989). Moreover, the further ambition that design must cultivate is that the industrial product, as well as being useful, efficient, ergonomical, ecological, etc., should also be human. And in order for it to be human, research must take another look at visual charm and plastic beauty. The moment has arrived to become reconciled with things,

recognizing that they have a sensitive soul. To attribute sensitivity and intelligence to apparently inert objects may appear absurd. It is not, if they are considered as extensions of our bodies. If the scythe and sickle can be seen as a sort of monstrous fingernail to lengthen our hands (Pierre Levy, *Tecnologia dell'intelligenza*, A/traverso-Synergon, 1992), the brassiere is a successful exuberance of the female bust. As such it is intimately connected to the body and its language. It makes itself part of the body to trigger reactions of complicity, to launch the eternal game of seduction. The theme this design project reveals is particularly intriguing: it is not a question of designing mute things which are born already dead, but participative objects which

place themselves at the center where desirous gazes are exchanged, capable of understanding and "intimate" relations with their users. Perhaps for this reason the creative responses to Samuele Mazza's call. He asked stylists, artists and designers to create a bra for his collection, and they were generous in inventions and transgressions. It is the merit of the theme if the project designers found, each in their own way, a warm energy, and they came out of the labyrinth of mannerisms and replicas in which they seem to be irremediably losing themselves today. The result is a multiform and unpredictable repertoire; difficult to

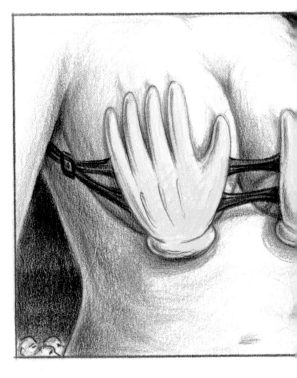

Luigi Serafini, *Reggimano* (Handy bra), Milan, 1992

catalogue within the usual stylistic canons. Multiform, unrestrained perhaps, but not kitsch. Kitsch is something which opposes and

transgresses the norms of current good taste. But in this case we are travelling so far above the rules, in another dimension, that has nothing in common with the realm where good taste abides. Yet

these are not phantasmagorias, but functional objects: each of the two hundred bras is in fact wearable, built to perform a precise function. These are not useless gadgets, but full-fledged products in which finally the aesthetic dimension merges with that of use. Though they have all the requisites to be defined as design and art, the current aesthetic vocabulary is too poor to provide an exhaustive description of this exhibition. We

can speak of neo-baroque, of punk, of minimalism, of structuralism, of ready-made, of high-tech and high-touch, of surrealism, of

Aldo Cibic,
Teneramente prigioniere
(Tenderly trapped),
Milan, 1992

abstractism, of citationism, of liberty, of deco, of pop, bringing in all the stylistic currents from the far and recent past. But how do we define the brassiere made of movie film, or the defensive bra bristling with pins, or the one with its cups padded with candy, etc.? Perhaps, if we wish to look for some common denominator, it is a good idea to investigate the materials: from this point of view too the theme of the design project has proven to be a good testing ground from those seeking original applications for natural and artificial materials.

Brahaus is one of the most interesting surveys of the possibilities for the use and expressiveness of materials. The bra becomes a stimulus for the artist to draw secrets and unexpressed magic from the most disparate of materials, and opportunity for imprudent technological and symbolic transferences. In short, this is an astounding exhibition, a variegated collection of hybrids and contaminations, an inextricable artistic Babel. It is vain to try to find a dominant stylistic thread: there is everything, and everything is proffered with generosity, without restraint. If there is a common tendency, then it is exuberance: a happy, uninhibited exuberance which sets itself in opposition to the general prudence, the widespread mannered

composure usually associated with this garment. The value of this exhibition is its capacity to make us aware of a non-verbal harmony, to reawaken us from the apathy of the familiar, to detoxicate us from the overdose of pale, authorized signs. It is amazing the stories that each bra reveals: a vast repertoire of desires and phobias, manias and obsessions, sublimations and exorcisms. We are spectators to a gripping story that emerges through improbable allusions, though keeping itself pure. We are captivated and involved by the succession of solutions as in the best adventure films, and projected into a galaxy where the reigning law is that of eroticism. Since these times are sparing with vital creative expressions, we suppose that it may be

this eroticism that has freed artists, designers and stylists from their own appointed identities, giving wings to their fantasies, too often mortified by the codes of good manners. Extraordinary stories do not only take place at the movies; to varying degrees they also occur in real life. But there is such resistance, through inertia and melancholy, to their manifesting themselves, that we often willingly deprive ourselves of them. Fortunately *Brahaus*, two hundred extraordinary, improbable brassieres created using the most unthinkable materials, does exist, and is here before your eyes.

Cristina Morozzi

Edible and Domestic

To suck and munch, tasty and greedy at the mother's breast. Housewifely, made of cheese-graters, teapots, coffee cups . . . tiny objects for daily use, from the realm of domestic ritual and myth. Improbable bras, slightly serious and slightly joking, tell of the dangerous relationship between the breast and motherhood, between femininity and domesticity.

Smiling and cutting metaphors represent without inhibition the sweet and bitter sentiments linked to the breast and the brassiere.

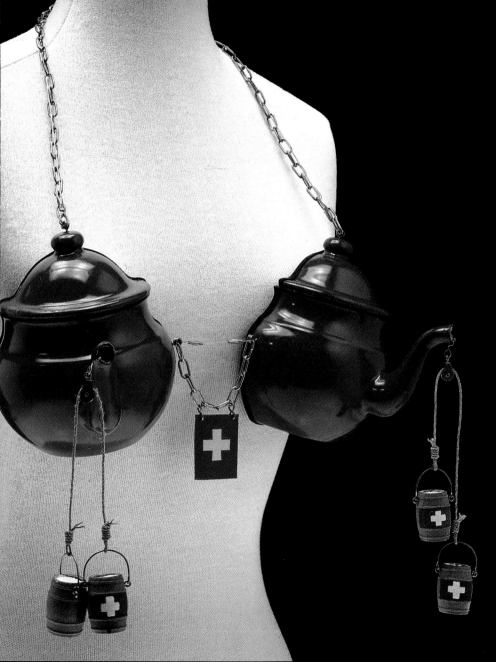

PRECEDING PAGE:
Marco Lucidi Pressanti,
Prima colazione a Ginevra
(Breakfast in Geneva),
teapots,
Rome 1992.

Vincenzo Lauriola,
Giardino pensile
(Hanging gardens),
terracotta and synthetic
flowers,
Florence 1992.

Dora Grieco,
Una tira l'altra
(Bet you can't eat just
one),
wood and fabric,
Florence 1991.

A. and G. Grimoldi,
Lunettes
(Sunglasses),
sunglasses,
Varese 1991.

Lorella Santoni,
Seno al dente
(Bosom al dente),
net and pasta,
Florence 1990.

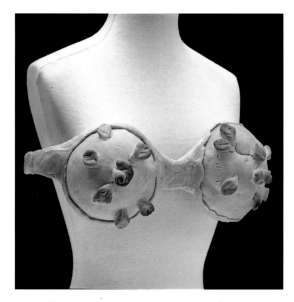

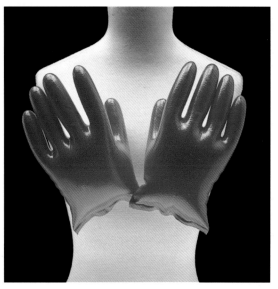

Edoardo Malagigi,
Pane quotidiano
(Daily bread),
plasticine and bread,
Florence 1991.

Ernesto Spicciolato,
Ritocco
(Touch-up),
plastic,
Milan 1991.

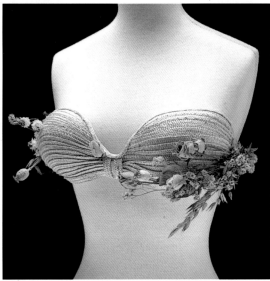

Biagio Cisotti,
Mulino Bianco
(Nature's bounty),
straw,
Florence 1991.

Elena Fiorio,
Cortesie per gli ospiti
(Party favors),
velvet and sweets,
Milan 1991.

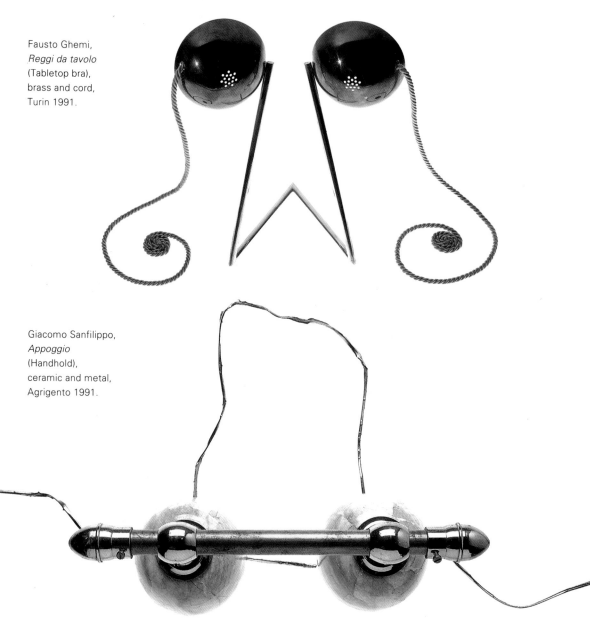

Fausto Ghemi,
Reggi da tavolo
(Tabletop bra),
brass and cord,
Turin 1991.

Giacomo Sanfilippo,
Appoggio
(Handhold),
ceramic and metal,
Agrigento 1991.

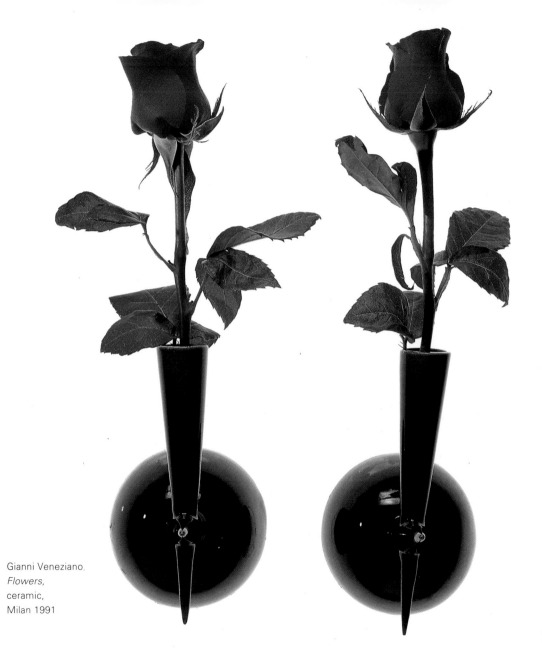

Gianni Veneziano,
Flowers,
ceramic,
Milan 1991

29

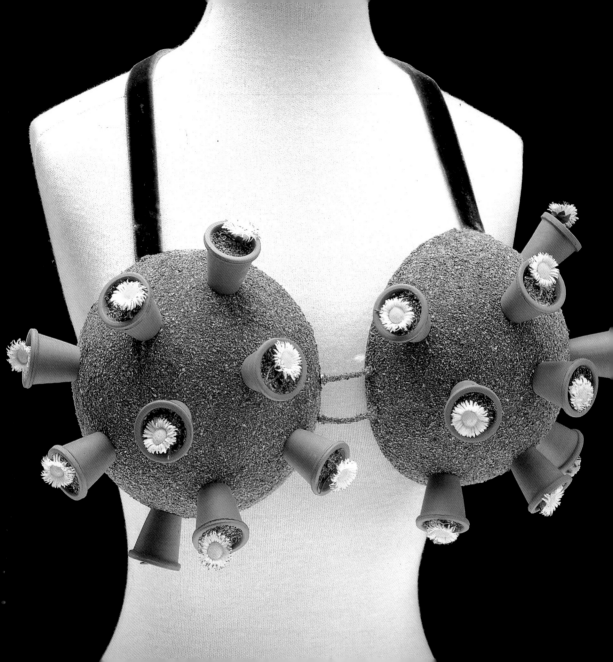

Mirella Jacovangelo,
Oltre il giardino
(Modern garden),
iron and plastic,
Lucca 1991.

Luciano Landi,
Chicchirichì Cocoricò
(Crowing match),
ceramic,
Florence 1991.

Lorenzo Gemma and
Ernesto Bartolini,
Design è astrazione
(Design is abstraction),
funnels,
Florence 1991.

A. and G. Grimoldi,
Rotondità
(Round and round),
drawing-pins and
compasses,
Varese 1990.

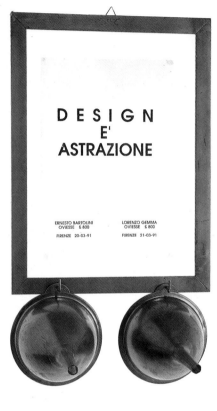
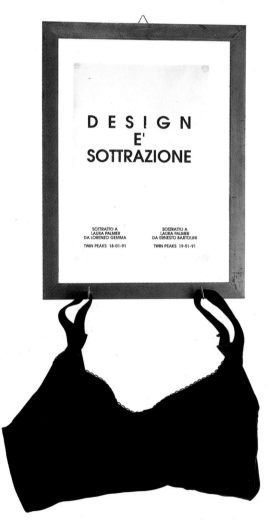

Lorenzo Gemma and
Ernesto Bartolini,
Design è sottrazione
(Design is subtraction),
brass and glass,
Florence 1991.

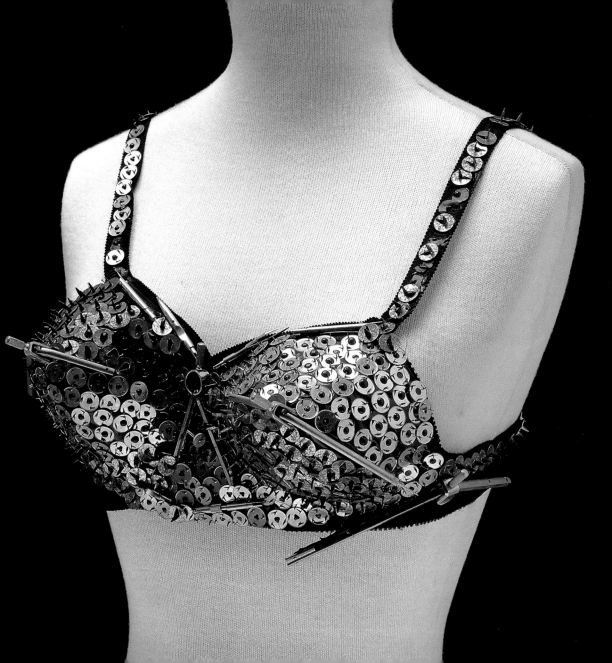

Cristina Medea,
Scola-Lusso
(Strainers deluxe),
metal and spangles,
Madrid 1991.

Giuseppe Piccione,
La Parmigiana
(Bust alla Parmigiana),
metal and leather,
Syracuse 1992.

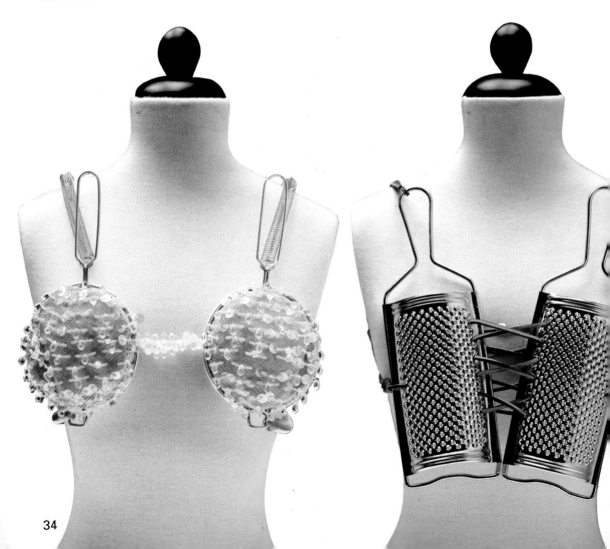

Carla di Fonzo,
Reggi-Flex
(Spring loaded),
metal and plastic,
Grosseto 1990.

FOLLOWING PAGE:
Giuseppe di Somma,
Reggi-Netto
(On tap),
brass,
Florence 1990.

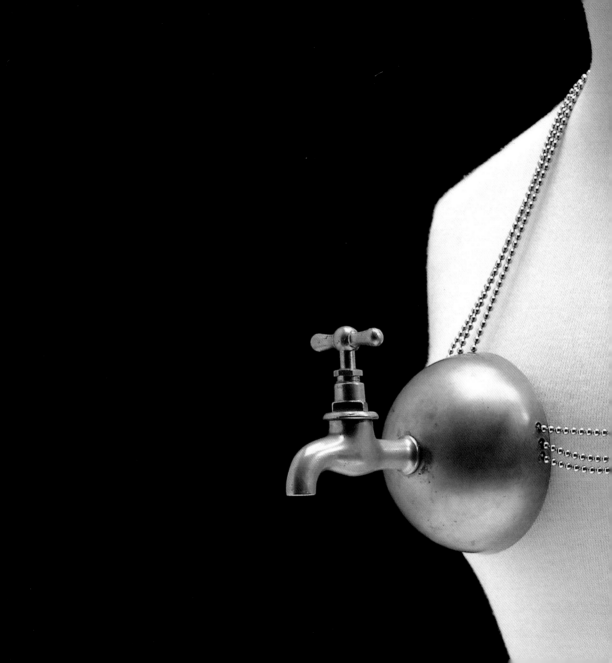

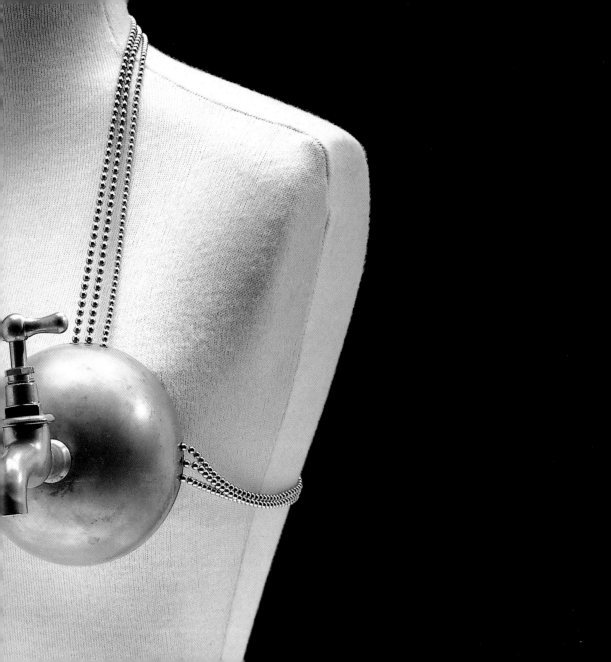

Giorgio Davanzo,
Merry Christmas,
plastic and canvas,
Venice 1991.

Antonio Saporito,
Bis
(Encore),
metal,
Florence 1991.

Milena Bobba,
Mai più il bucato
(The last load),
cardboard, wood and iron,
Ravenna 1991.

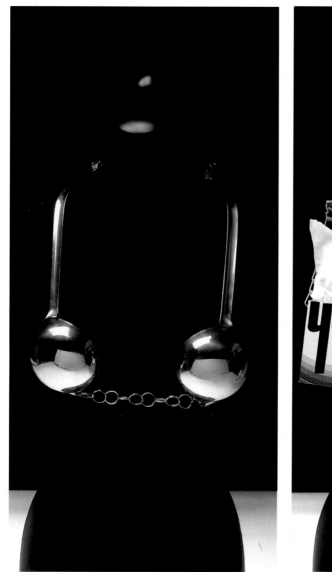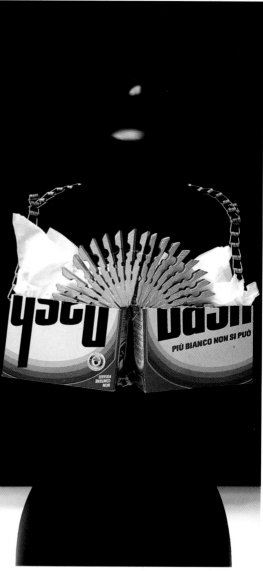

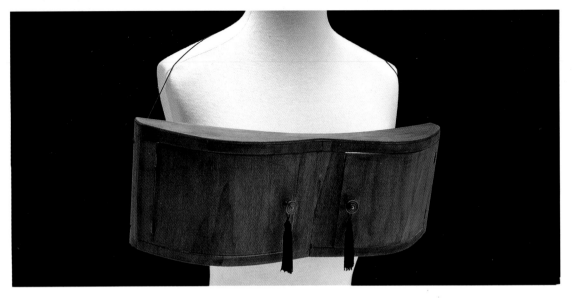

Samuele Mazza,
Non aprite quella porta
(Don't open that door),
wood,
Florence 1992.

Gianni Monini,
Carosello
(Billboard bra),
plastic coated photo-
graphs,
Florence 1991.

Monica Leoncini,
Reggi-in-mobile
(Wooden chest),
wood,
Florence 1992.

Paola Monguzzi,
Reggi-tea-tazze
(Tea cups),
plastic, aluminum, fabric,
Bergamo 1991.

41

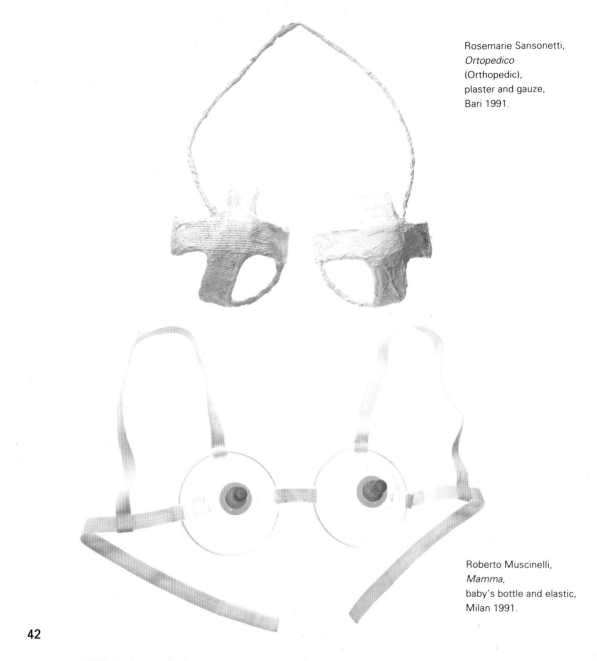

Rosemarie Sansonetti,
Ortopedico
(Orthopedic),
plaster and gauze,
Bari 1991.

Roberto Muscinelli,
Mamma,
baby's bottle and elastic,
Milan 1991.

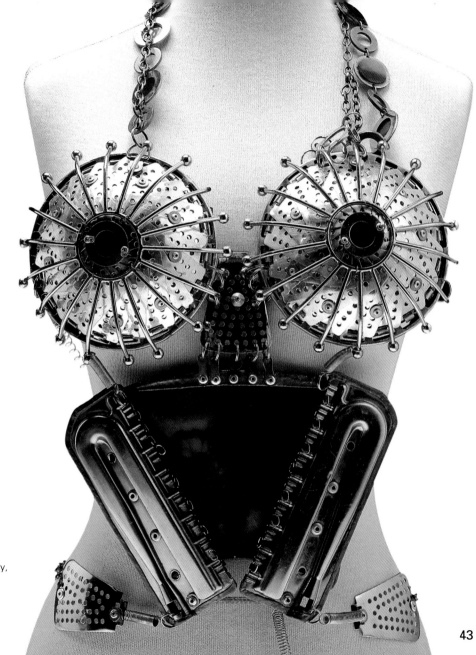

Regine de La Hey,
Steaming Hot,
metal,
London 1991.

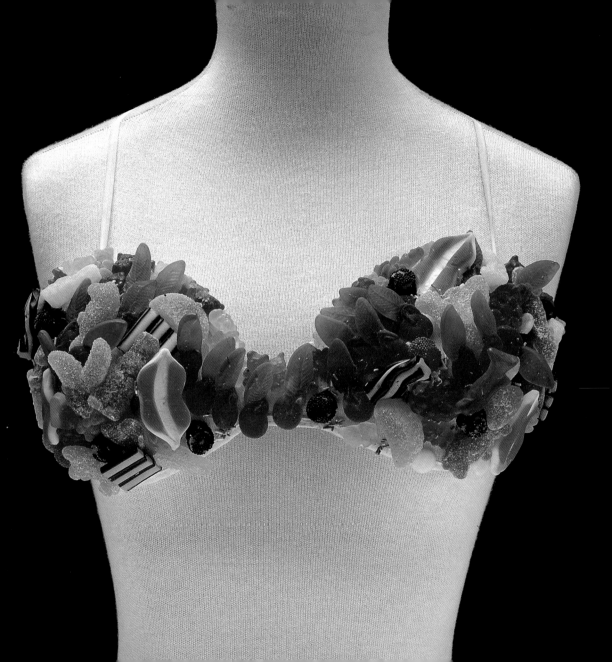

Sandra Laube,
Reggi-Masticabile
(Candy bra),
sweets,
Florence 1991.

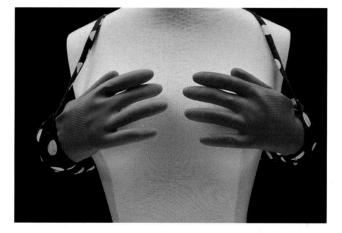

Patrizia Ledda,
Agguantami
(Hold me),
cloth and rubber gloves,
Milan 1991.

Santi Rinciari,
Panoramico
(Balcony with a view),
aluminum,
Messina 1990.

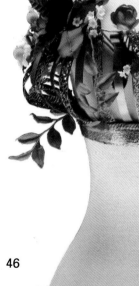

Samuele Mazza,
Reggi-Elisabetta
(Queen Elizabra),
clay and chain,
Florence 1992.

Paolo Cotza,
Povera Crista
(Poor kid),
barbed wire,
Turin 1991.

Simona Patrucco,
Reggi-Caramel
(Custard cups),
tongs and creme caramel
molds,
Turin 1990.

Alberto Pisano,
Giugno
(June),
bread,
Florence 1991.

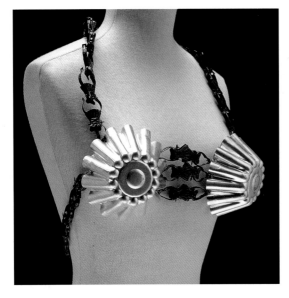 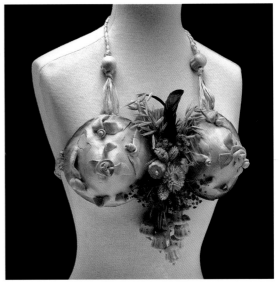

Cinzia Vizzielli,
Ben conservati
(Well preserved),
tin and brass,
Taranto 1992.

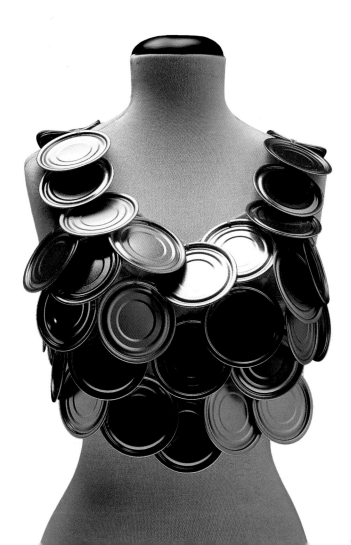

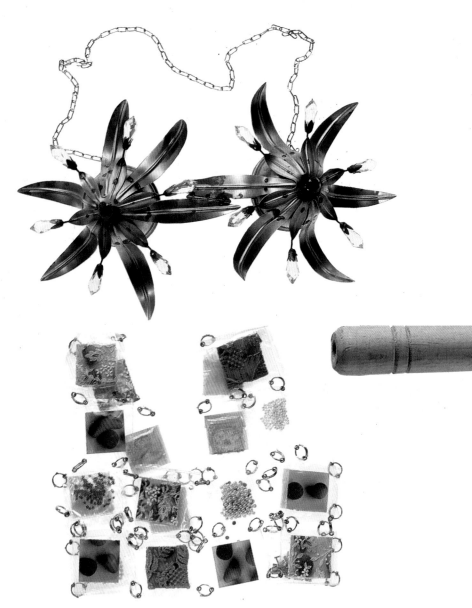

Nicola Falcone and
Monica Leoncini,
Barocco
(Baroque),
metal and glass,
Florence 1990.

Hilary Kirby,
Brunch,
vacuum-pack bags,
London 1990.

50

Stefano De Angelis,
Sturaseno
(Plumber's friends),
suction cups,
Florence 1990.

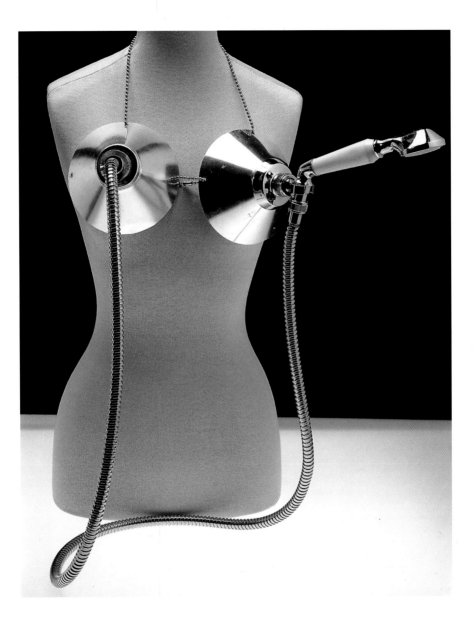

Giuseppe di Somma,
Doccia di latte d'asina
(Milk bath),
stainless steel,
Florence 1990.

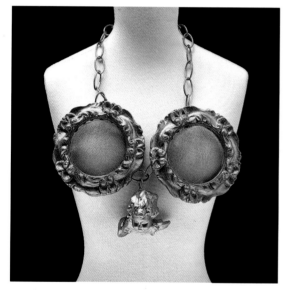

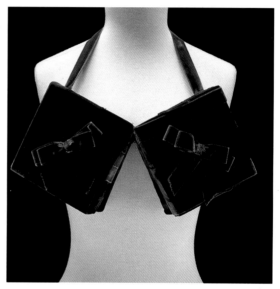

Ludwig Hartmann,
Come eravamo
(The way we were),
picture frames,
Ecuador 1991.

Fabio Bechelli,
Reggi-Sorpresa
(Surprise),
cardboard and velvet,
Florence 1992.

Mechanical
and Dynamic

They light up and go off, they open
and close, they go round and round,
they twist in spirals in the air, they
are tightened like harmonic strings.
These are the technological bras: rigid
as breastplates, flexible and mobile
as Calder sculptures, operational as
everyday devices, for illuminating, ven-
tilating, and for showering. A mechanical
procession of unsettling and provocative
bras which appear to be created not for the soft
curves of women of flesh and blood, but for the torsos
of replicants and robots.

Mirella Jacovangelo,
Bimotore
(Biplane),
sheet steel, small motor,
propellers,
Lucca 1991.

55

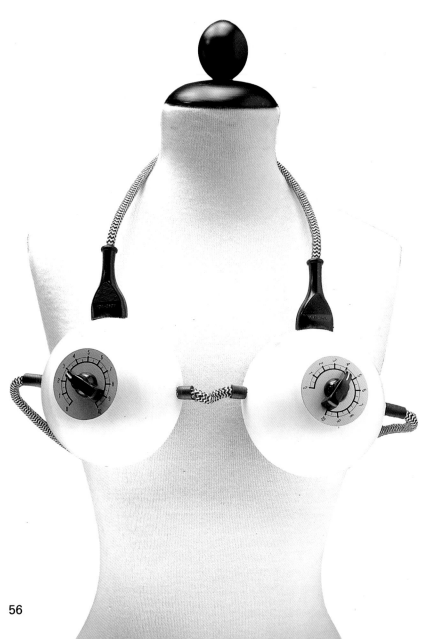

Miguel Pizzorno,
Scaldaseno
(Breast warmer),
thermal objects,
Paris 1992.

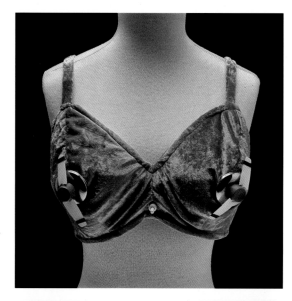

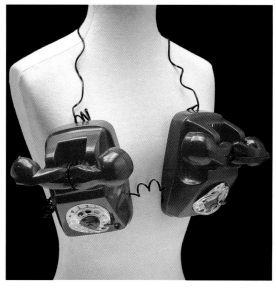

Moreno Vallini,
Calmabollori
(Soothe the savage
breast),
material and plastic,
Ancona 1991.

Annalisa Giganti,
Seno Squillo
(Call me),
plastic telephones,
Agrigento 1990.

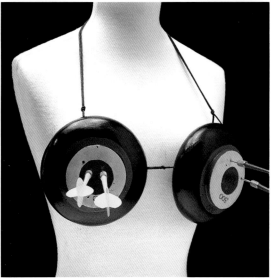

Lars Hagen Duellfer,
Al centro dell'attenzione.
(Bull's eye),
Kassel 1990.

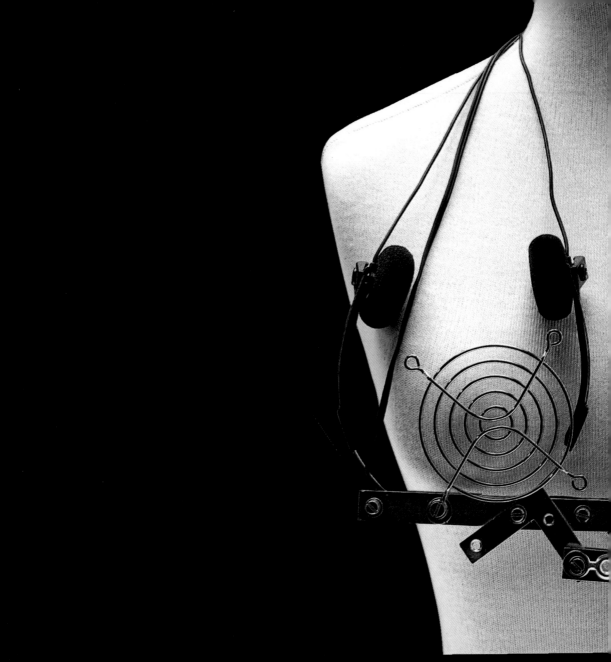

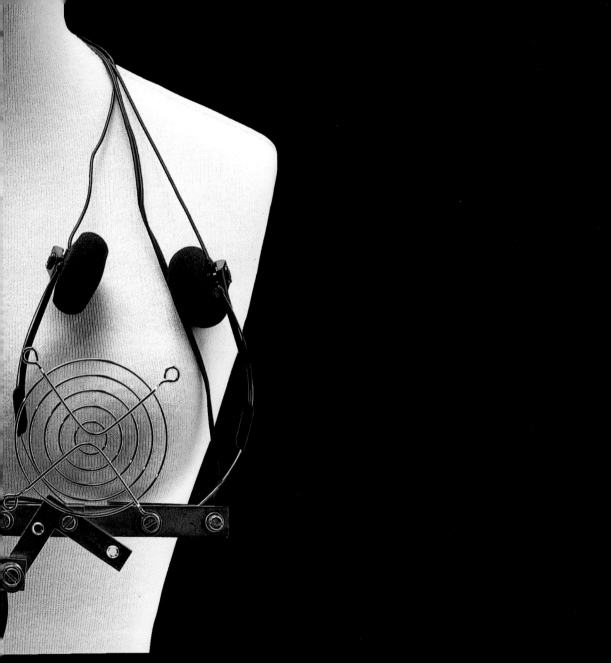

PRECEDING PAGE:
Angelo Jelmini,
Reggi-Sento
(Wired for sound),
acoustic materials,
Milan 1991.

Riccardo Misesti,
A luci rosse
(Red light district),
metal and enamel,
Florence 1992.

Guiseppe di Somma,
Reggi-Mondo
(World cups),
plastic and metal,
Florence 1990.

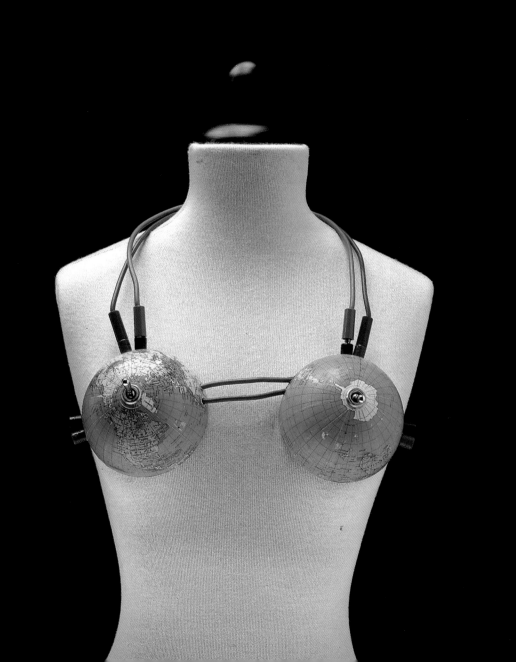

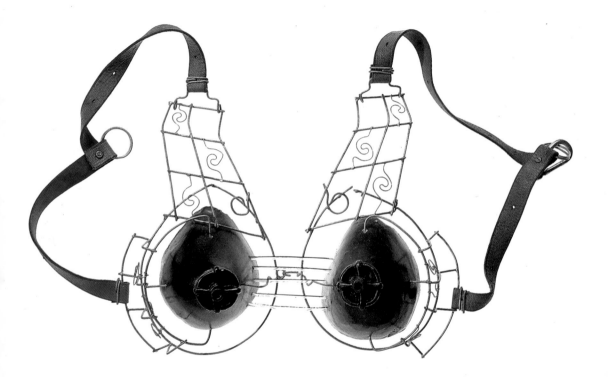

Stelios Paradakis,
Bombs,
metal and leather,
Florence 1992.

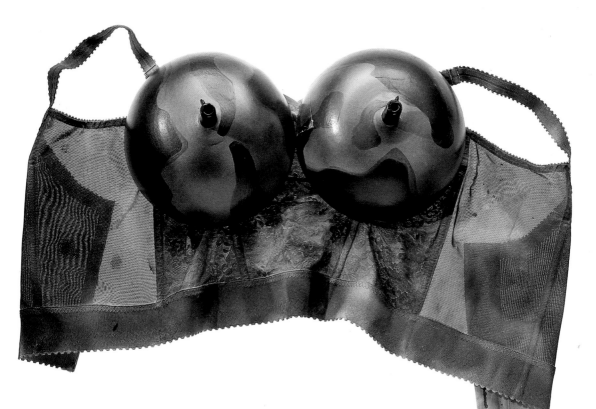

Sergio Fabio Rotella,
Tette nel deserto
(Desert gear),
ceramic and cloth,
Milan 1991.

Paola Mey,
Reggi a sonagli
(Jingle bells),
cloth and bells,
Florence 1990.

Andrea Virgili,
Hi-Fi,
iron and spare parts,
Florence 1990.

Ruth Lawrence,
Kensington Bra,
metal,
London 1990.

FOLLOWING PAGE:
Olivier Guillemin,
La cage au gorge
(Breast cage),
iron,
Paris 1992.

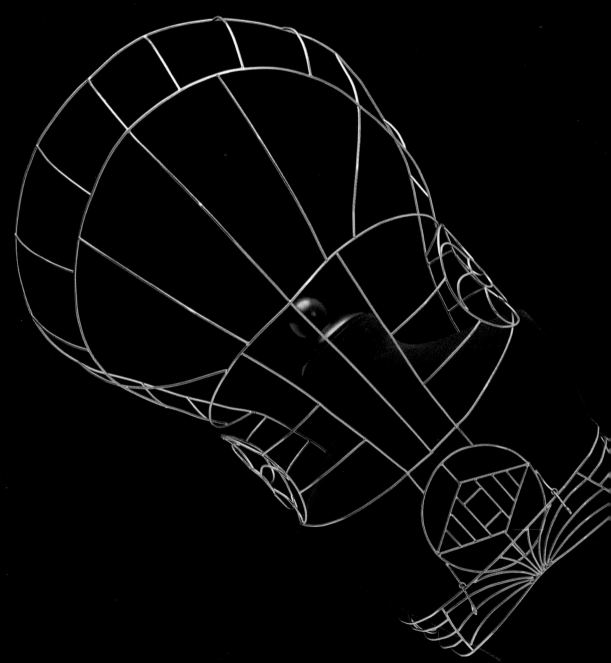

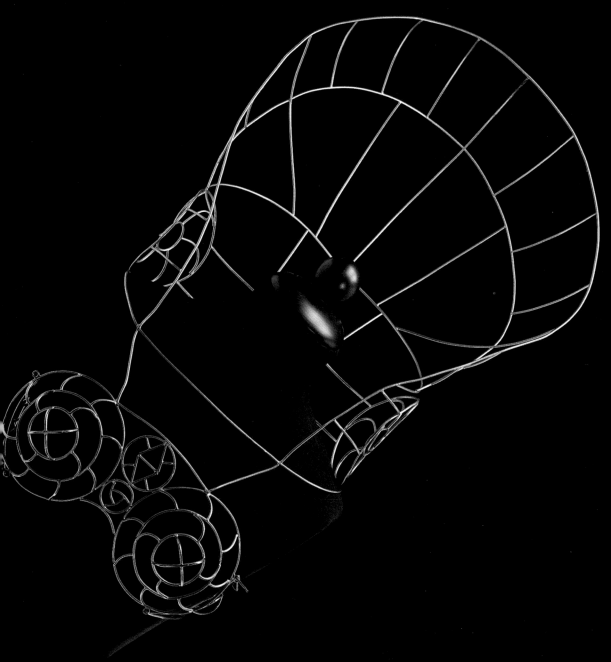

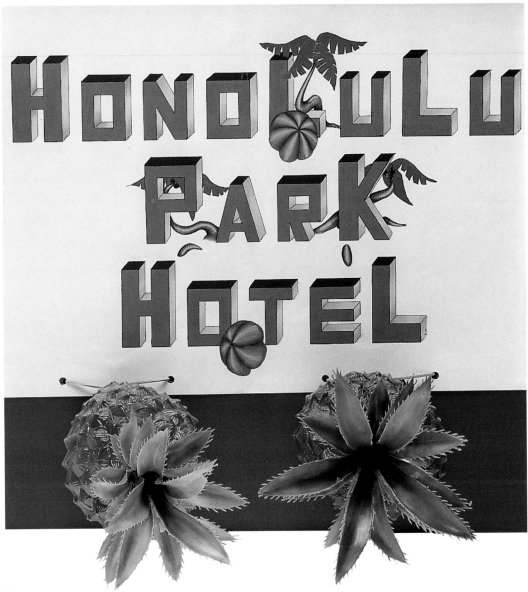

Guisi Viola,
Hawaiiana
(Hawaii),
paper and plastic with
internal mechanisms,
Catania 1992.

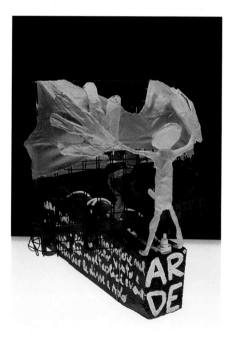

Arde Peintre,
Obsession,
wood, plastic and iron,
Milan 1991.

Angelo Jelmini,
Reggi-Sento
(Wired for sound),
speakers,
Milan 1991.

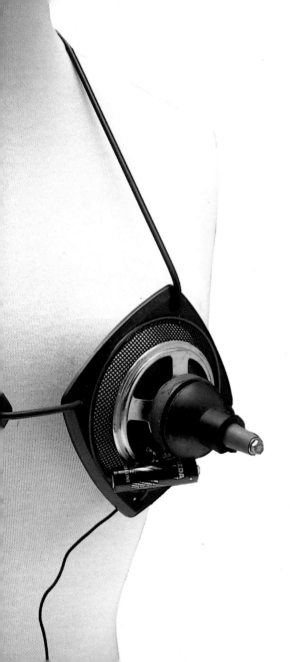

FOLLOWING PAGE:
Samuele Mazza,
Reggi-Secolo
(Timeless bra),
working clocks,
Florence 1991.

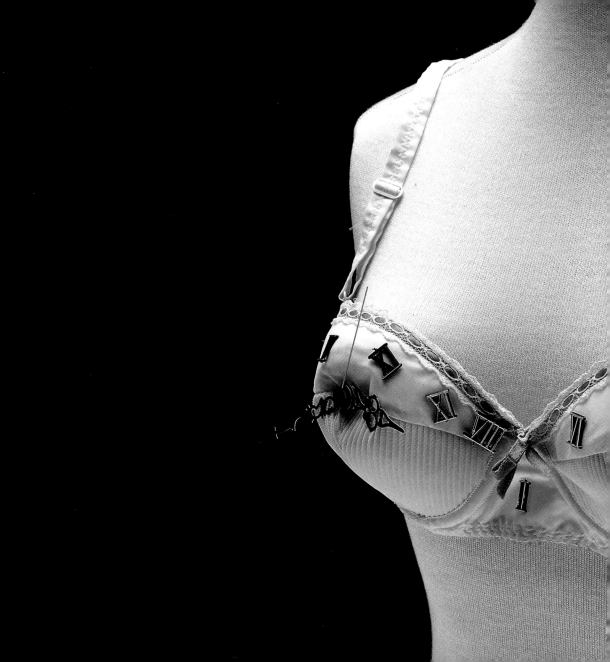

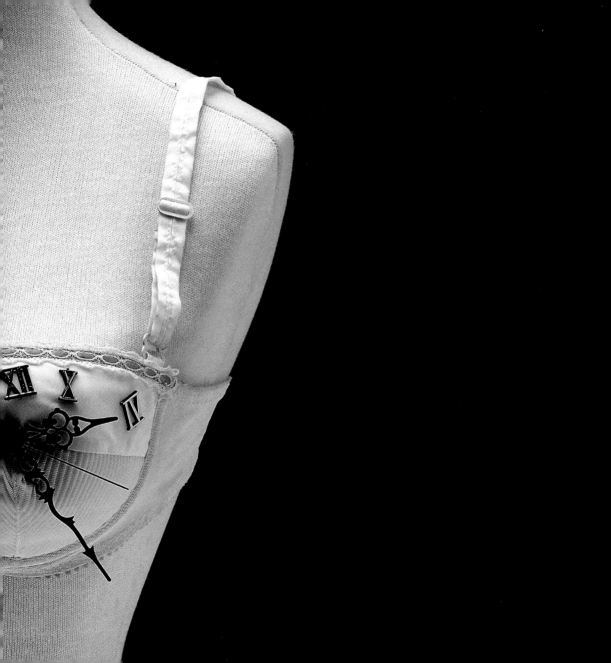

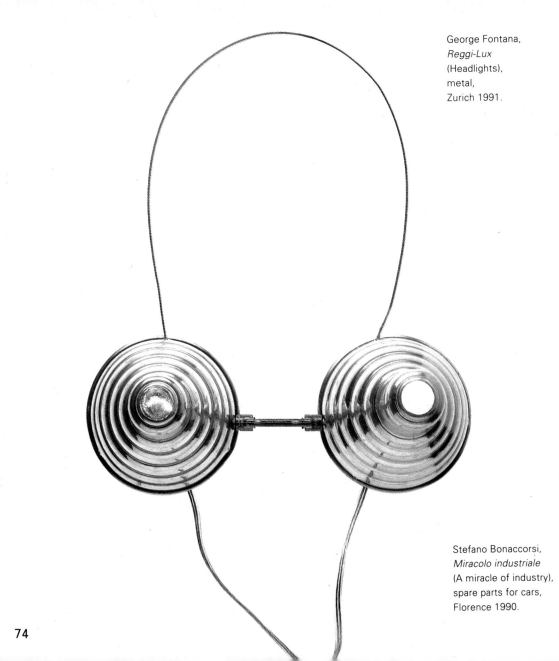

George Fontana,
Reggi-Lux
(Headlights),
metal,
Zurich 1991.

Stefano Bonaccorsi,
Miracolo industriale
(A miracle of industry),
spare parts for cars,
Florence 1990.

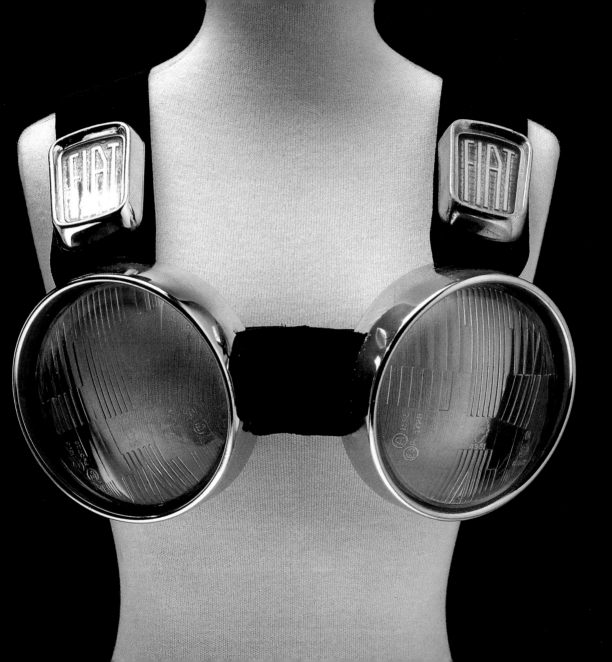

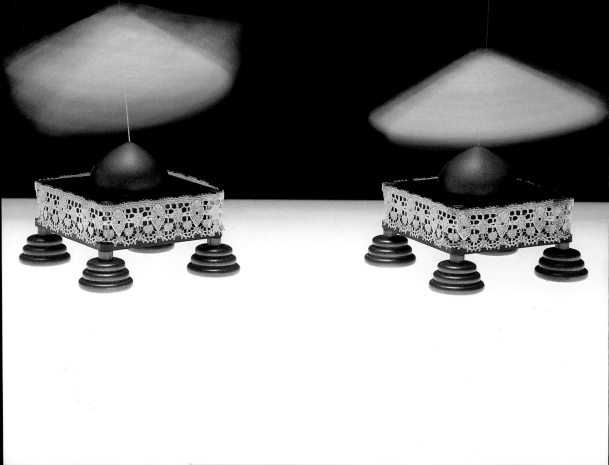

Ronnen Joseph,
Tette al vento
(Caught in the wind),
plastic and fan mecha-
nisms,
Tel Aviv 1991.

Giuseppe di Somma,
Permesso
(Coming through),
metal,
Florence 1990.

FOLLOWING PAGES:
Samuele Mazza,
Direzionato
(Well oriented),
seno destro, seno sinistro
(right breast, left breast),
straps and alarm clock
carcasses,
Florence 1991.

Anna Perico,
Vortice
(Vortex),
coated wire,
Milan 1991.

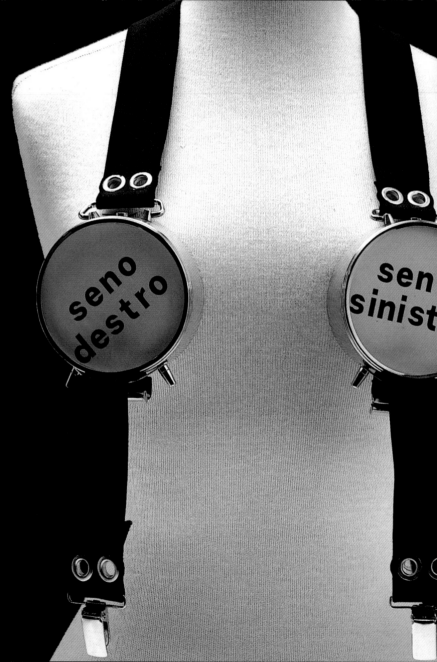

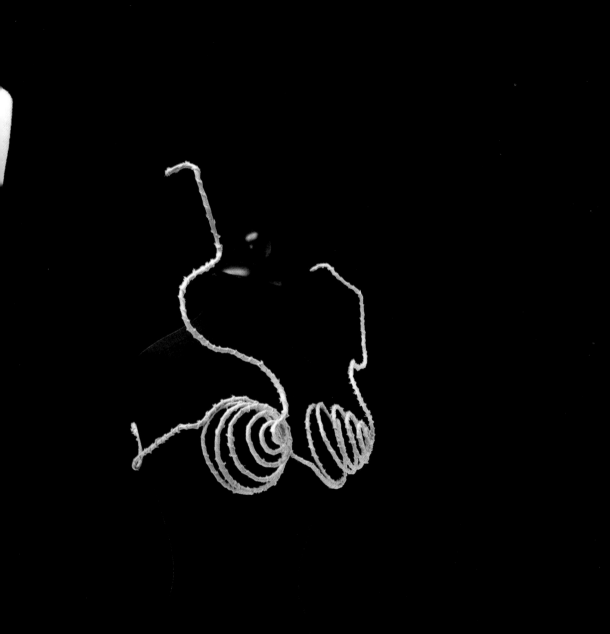

Primitive
and Natural

Daisies, cabbage and ivy leaves, rosebuds, stems of grass: a universe of vegetation and flower to transform metropolitan women into Botticelli Venuses. Bristles, furs, raffia, string to weave together cups and straps of primitive flavor, dedicated to warrior women from the stone age, or to out and out naturists. And finally a little healthy regression in form to unpredictable brassieres, similar to sci-fi landscapes inhabited by tiny prehistoric monsters in soft, colored rubber, for lady Lolitas who amuse themselves with seduction.

Andrea Blum,
Fishing,
rusty iron,
New York 1990.

81

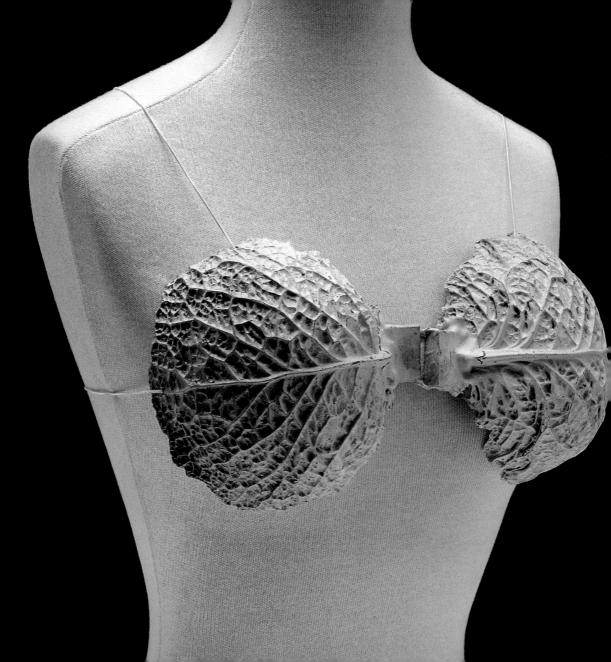

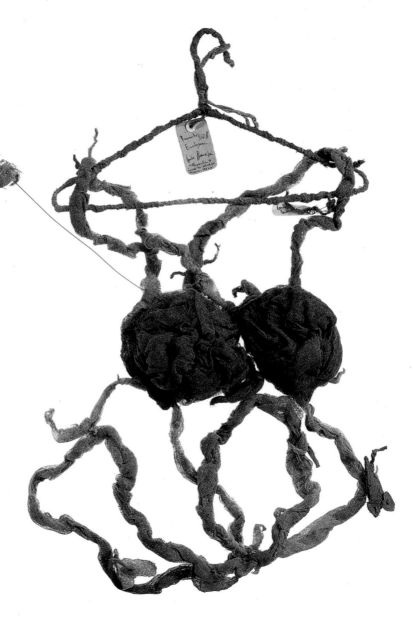

Carla Barnabei,
Répêchage
(Fishing),
material,
Milan 1991.

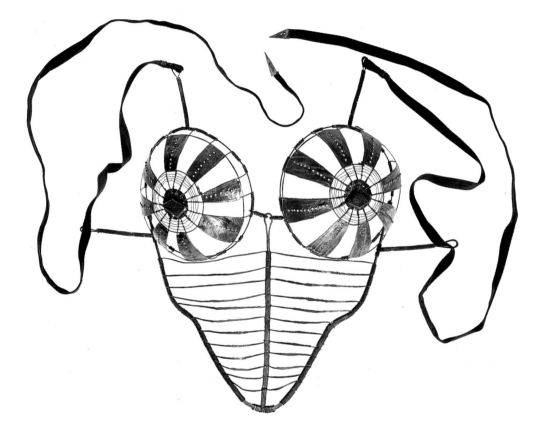

Wunderkammer Studio,
Gabbia toracica
(Rib cage),
iron and velvet,
Milan 1992.

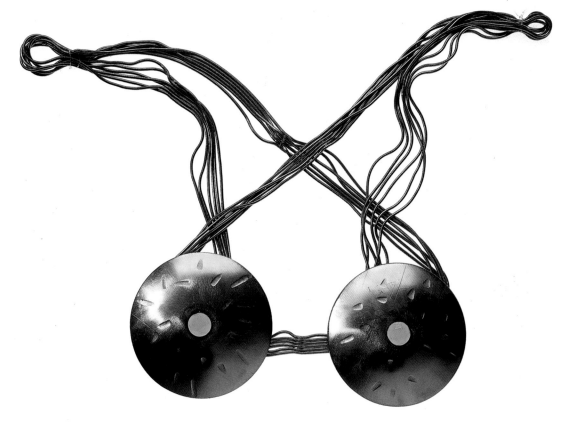

Santina Bonini,
La Fenicia
(Phoenicia),
metal and glass,
Milan 1991.

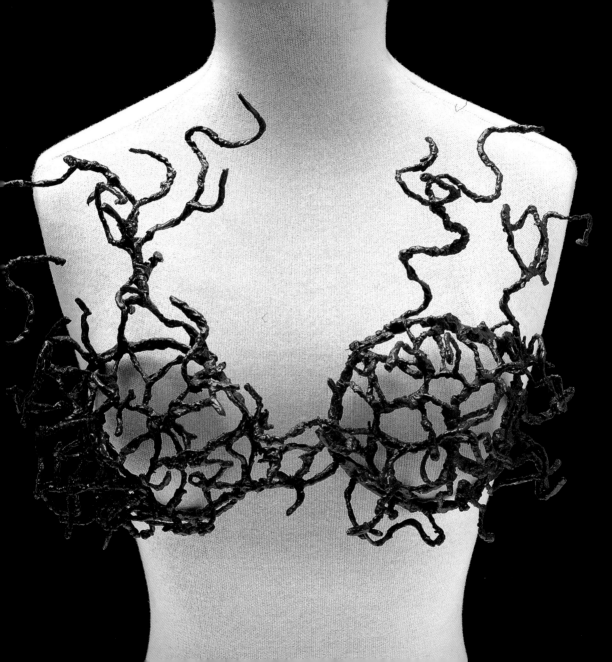

Antonio Marras,
Barriera corrallina
(Barrier reef),
wire,
Alghero 1990.

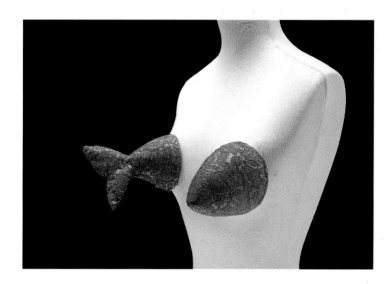

Andrea Salas Acosta,
Sano come un pesce
(Healthy as a fish),
foam rubber and cloth,
Puerto Rico 1991.

Gianfranco Pagnelli,
Orchidee selvagge
(Wild orchids),
plastic,
Bari 1992.

Giusi Mastro,
Amazzone
(Amazon),
leather,
Florence 1991.

A. and G. Grimoldi,
Shells,
shells and cloth,
Varese 1990.

FOLLOWING PAGE:
Silvio De Ponte Conti and
Alessandro Ruiz,
Aries,
latex and plastic,
Milan 1991.

Lars Hagen Duellfer,
Primitive,
painted chamois,
Kassel 1990.

Wunderkammer Studio,
Woo-doo
(Voodoo),
cloth and aluminum,
Milan 1991.

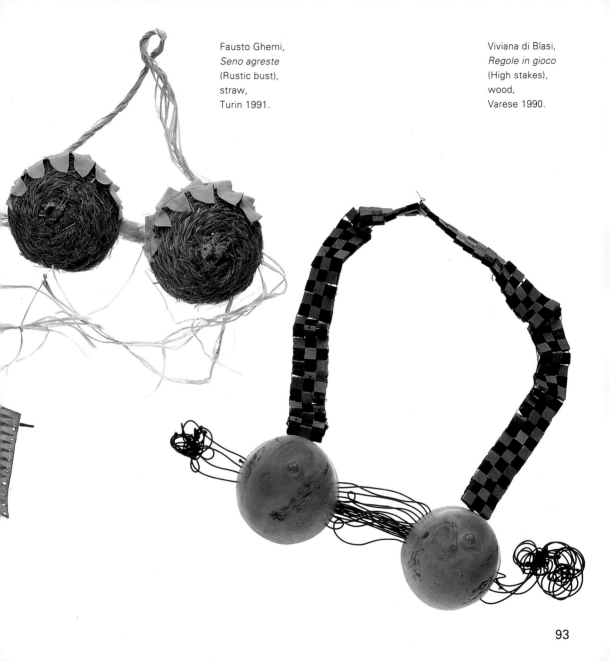

Fausto Ghemi,
Seno agreste
(Rustic bust),
straw,
Turin 1991.

Viviana di Blasi,
Regole in gioco
(High stakes),
wood,
Varese 1990.

93

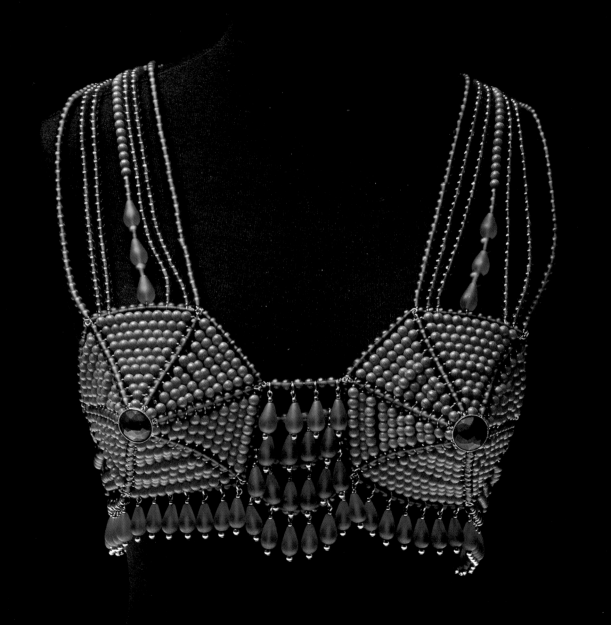

Yves Saint-Laurent,
Hommage d'Afrique
(Hommage to Africa),
brass and pearls,
Paris ca. 1970

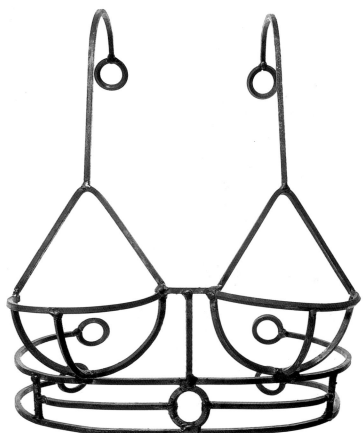

Phisizoa,
Robusta
(Robust),
iron,
Rome 1991.

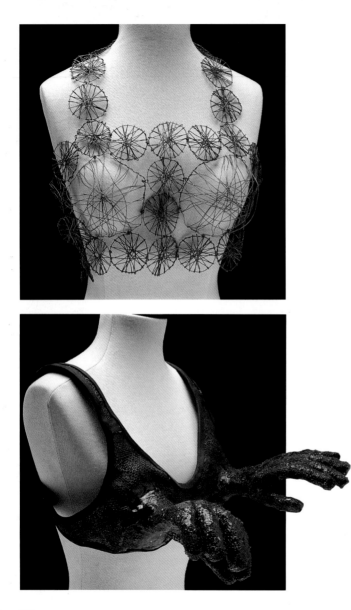

Elena Petrali,
Reclusa
(Guarded woman),
wire,
Brescia 1990.

Battaiotto Carlevaro
Venditti,
Le mani di Edward
(Edward's hands),
straw and silicone,
Turin 1991.

Kikka d'Ercole and Maria
Gallo,
Reggi-Sauro
(Bustosaurus),
plastic,
Milan 1991.

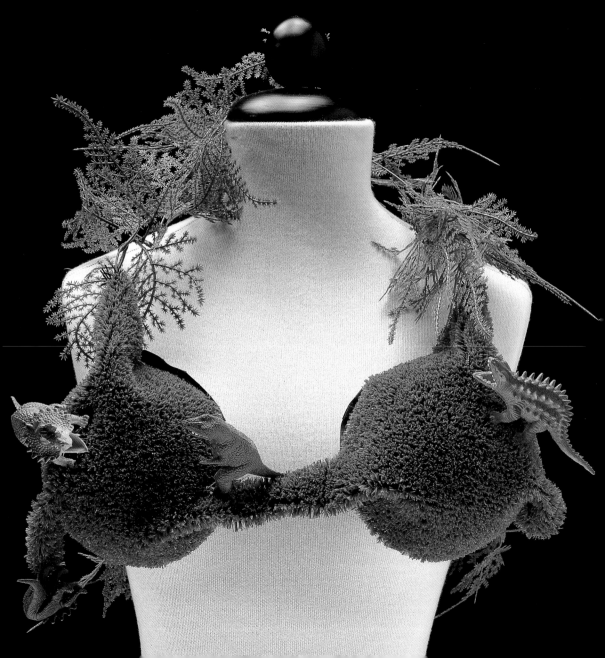

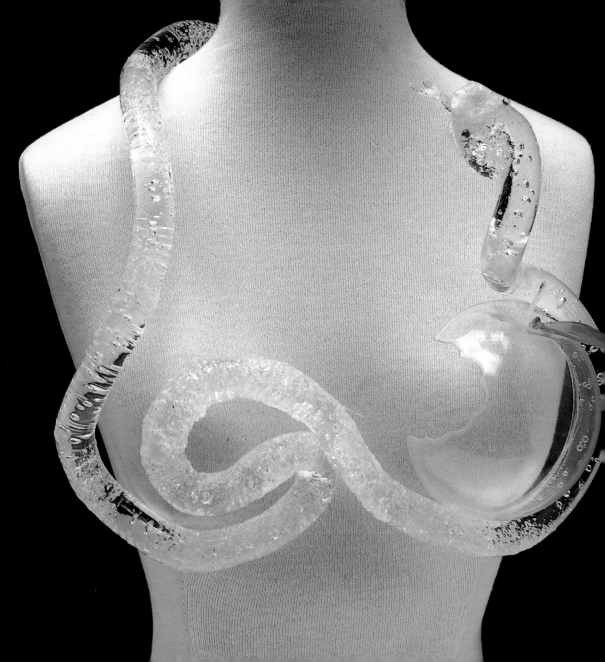

Ersilia Gargioli,
Tentazione di Eva
(Temptation of Eve),
glass,
Milan 1991.

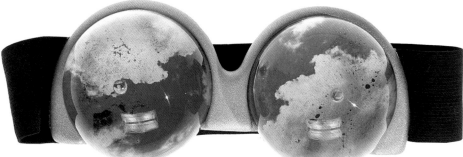

Maurizio Favetta,
Immagina
(Imagine),
"snowballs" and elastic,
Milan 1991.

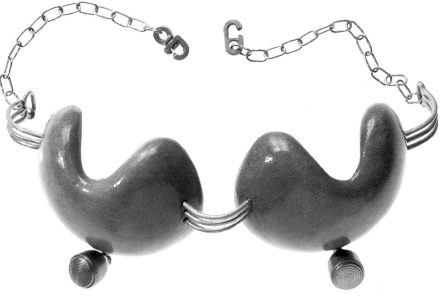

Massimo Accoto,
Mille Miglia
(Race track),
wood and metal,
Lecce 1990.

Izaskun Alberdi,
Tecno Eva
(Techno-Eve),
leaves and metal,
San Sebastian 1991.

Andrea Natt,
Blup
(Blue),
wire and lapis-lazuli,
Florence 1990.

Eleonora Botticelli,
Bouquet,
cloth,
Florence 1990.

Serrena Cartei,
Eva
(Eve),
silk leaves,
Florence 1991.

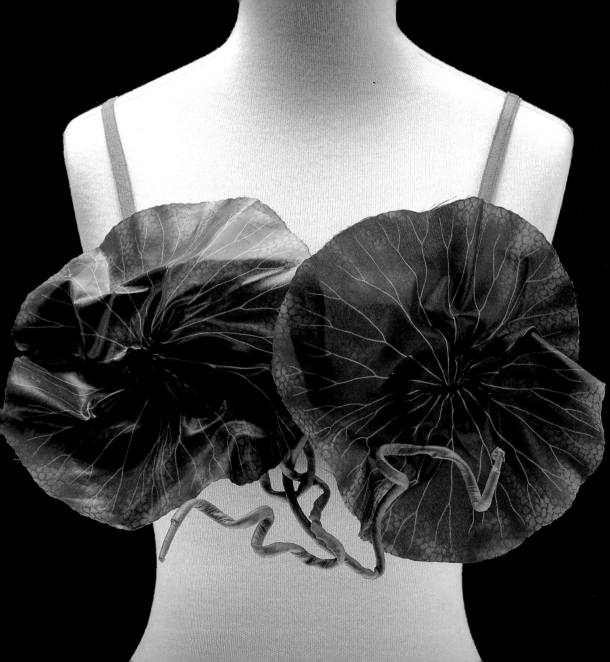

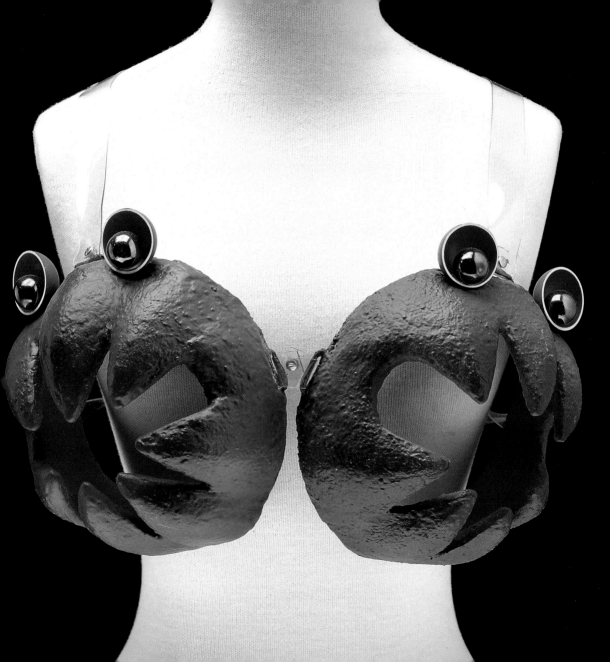

Alessandra Orlandoni,
Pak-tette
(Pac-Man),
polyurethane and spray,
Bologna 1991.

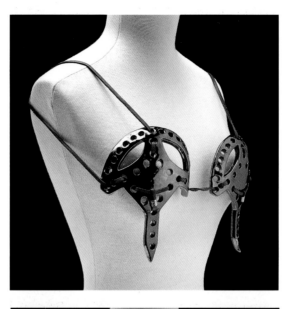

Sergio Binaglia,
Assiro-Babilonese
(Assyro-Babylonian),
ceramic,
Perugia 1990.

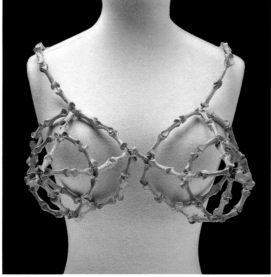

Alex Mocika,
L'Âge d'Or
(The golden age),
plasticine and iron,
Brussels 1991.

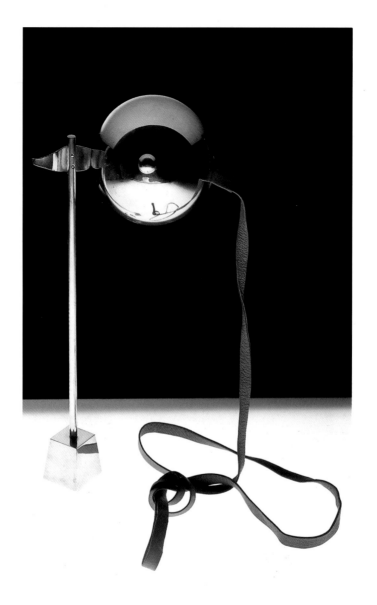

Edgar Vallora,
Amazzone
(Amazon),
silver,
Milan 1991.

Nunzia Paola Carallo,
Reggi-Fate
(Long-armed bra),
cloth and feathers,
Milan 1990.

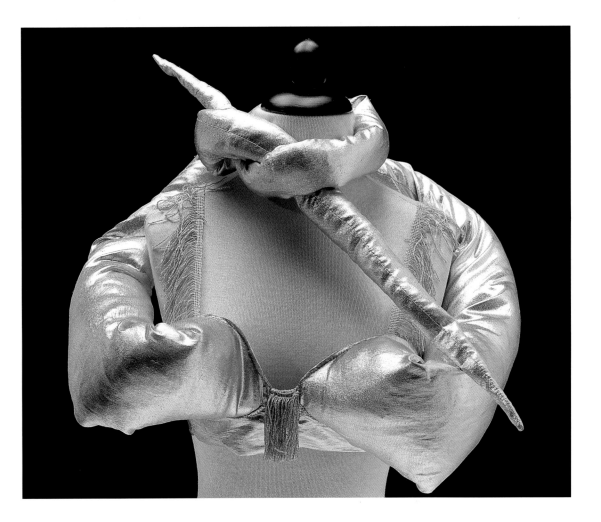

Simon Chalmers,
Bambra,
bamboo,
London 1991.

Franco Curletto,
Bella Mora
(Beautiful brunette),
hair,
Turin 1990.

FOLLOWING PAGES:
Pino Milella,
Lolita,
wire and stones,
Bari 1991.

Tarshito (Nicola Strippoli),
Amazzone
(Amazon),
wickerwork,
Bari 1991.

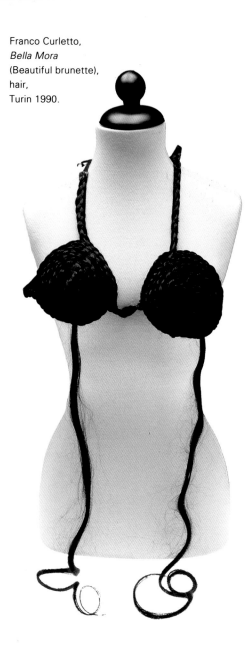

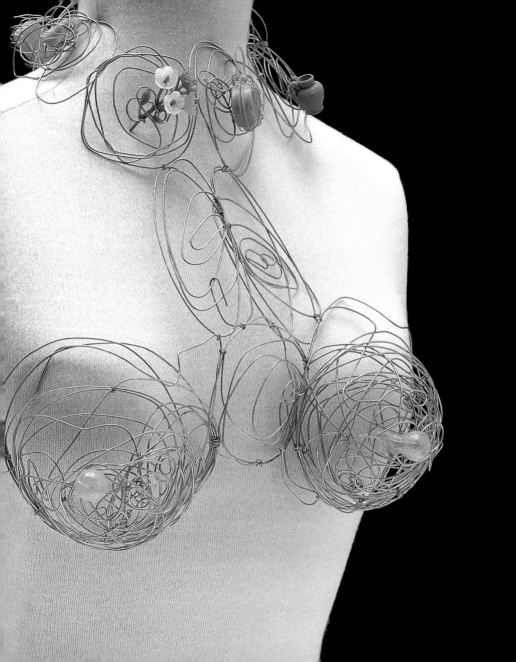

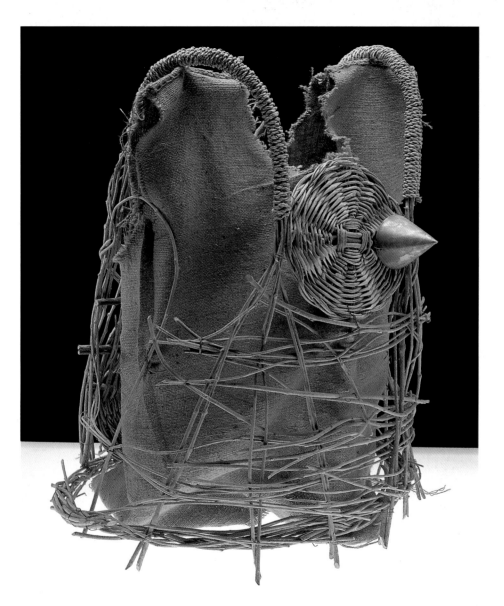

Urban and Perverse

Ribbons and asphalt, holiday postcards, balconies, gates, and plaster statues act as cups for bras with a metropolitan flavor. Eloquent metaphors for modern times open up artistic and folkloric urban pathways. Tourist bras devoted to students of art and lovers of baroque taste. Gloomy, perverse bras, bristling with pins and punches, rattling with chains and studs, dedicated to the people of the night.

Diana di Chiara,
Movie,
photographic film,
Florence 1990.

Art Jemeau,
Narciso
(Narcissus),
splinters of mirror,
Varese 1990.

Lars Hagen Duellfer,
Hey D.J.,
records and straps,
Kassel 1990.

Battaiotto Carlevaro
Venditti,
Traffico limitato
(Speed bumps),
tar,
Turin 1991.

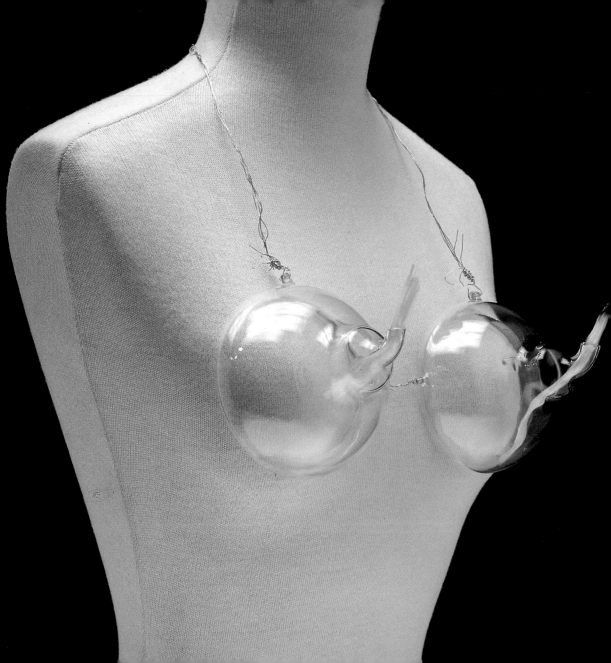

Prospero Rasulo,
Reggi-Aladino
(Aladdin's lamps),
glass and petroleum,
Milan 1991.

Julie Jones,
Rosebud,
leather and zippers,
London 1992.

Sergio Binaglia,
Sado-maso-chic,
ceramic and chain,
Perugia 1990.

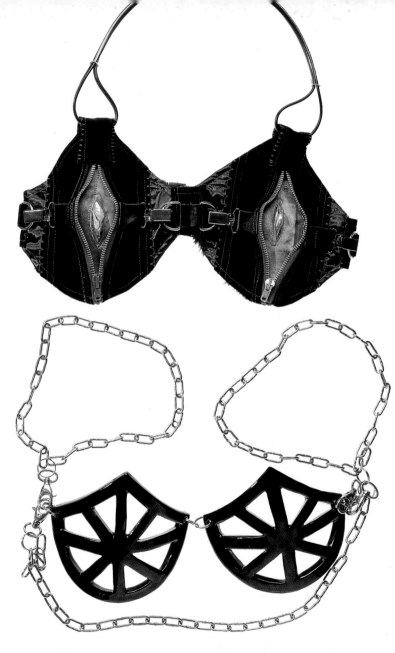

117

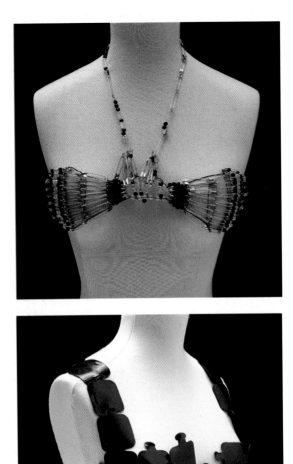

Maristella Puliti,
Balia
(Nursemaid),
safety-pins,
Florence 1992.

Paco Rabanne,
Puzzle,
plastic,
donazione V. Müstel,
Paris 1970.

Ritsue Mishima,
Le due gemelle
(Twin sisters),
velvet and frames,
Tokyo 1992.

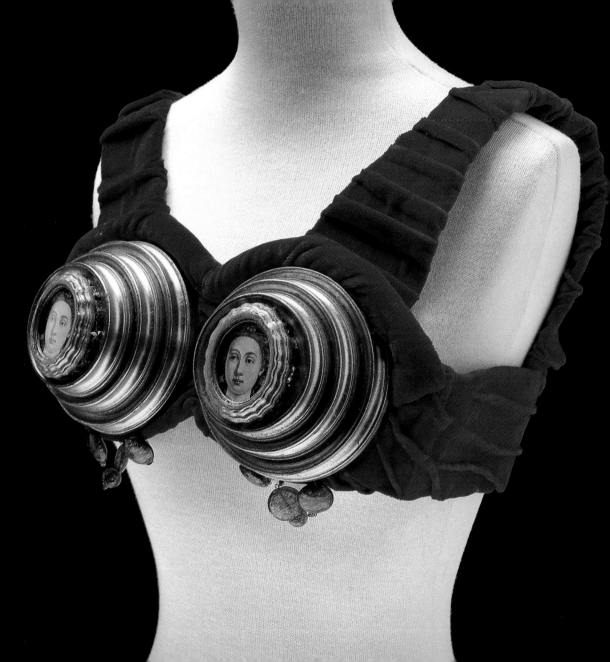

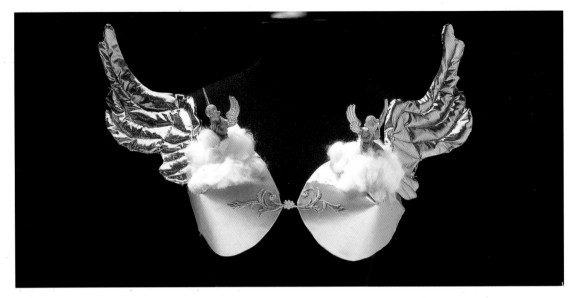

Kathy di Guglielmo,
Cielo, mio marito
(Good heavens, my
husband),
cardboard and material,
Toronto 1991.

Slavitza,
Odalisque,
sponge and pearls,
Beograd 1990.

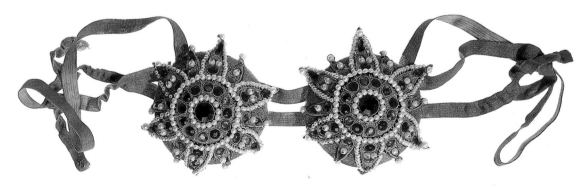

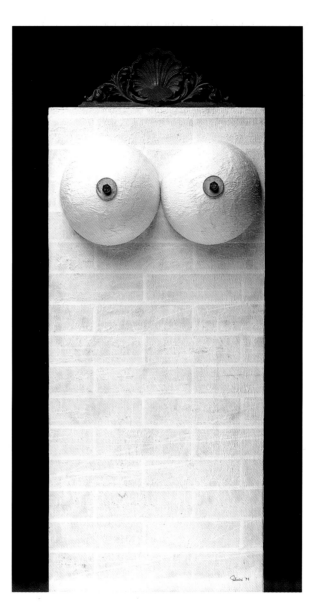

Mimmo Palmizi,
Il muro del pianto
(The wailing wall),
papier-mâché and wood,
Milan 1991.

Paola Marzotto,
*Questo è un gioco che ha
il suo significato-Il
reggiseno è un po'
superato*
(There's a moral to
relate—The bra is out of
date),
silver wire,
Milan 1991.

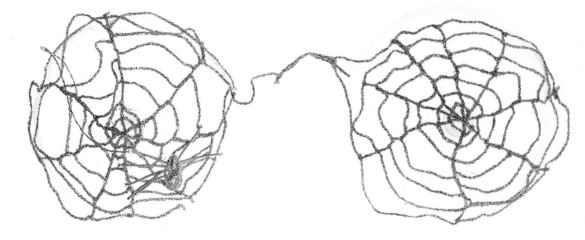

Elio di Franco,
Sinuosità
(Sinuous),
glass and metal sheet,
Florence 1992.

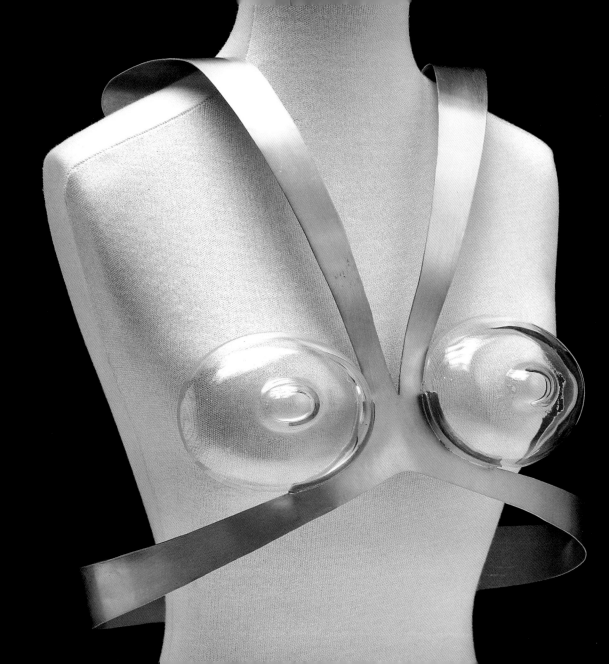

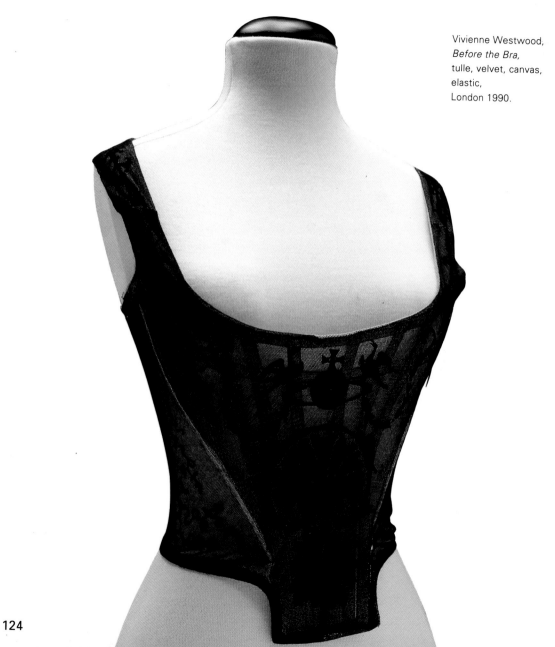

Vivienne Westwood,
Before the Bra,
tulle, velvet, canvas,
elastic,
London 1990.

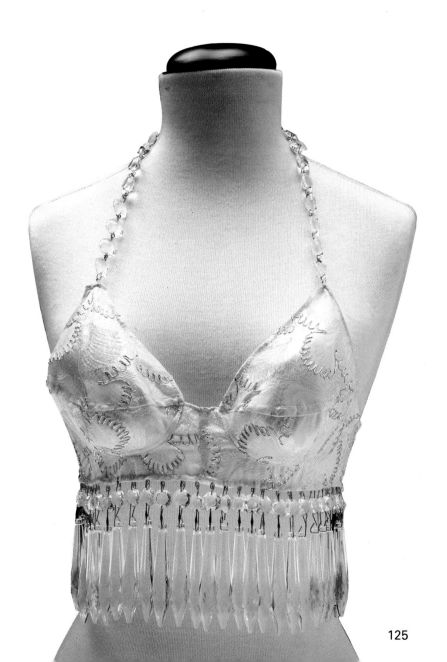

Camilla Cordella,
Lady Swarowsky,
crystals and cloth,
Florence 1990.

125

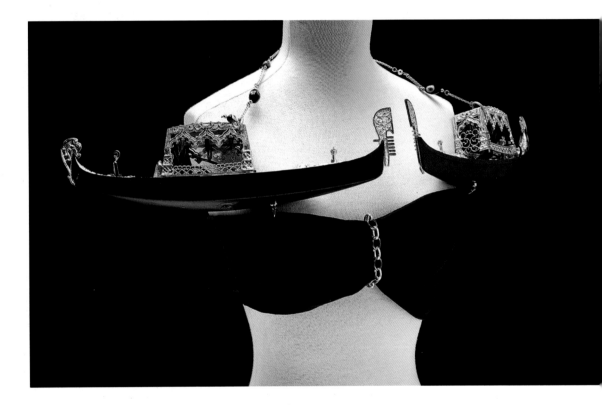

Silvia Bruschini,
Salvate Venezia
(Save Venice),
velvet and gondolas,
Rome 1991.

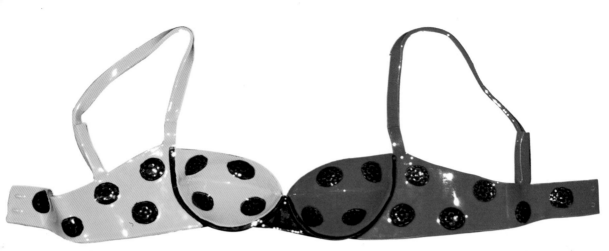

María Cristina Hamel, I,
Senza contenuto
(Unrestrained),
ceramic,
Milan 1991.

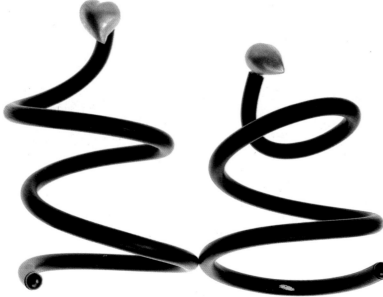

Vincenzo Russo,
Fino al cuore
(To the heart),
rubber and metal,
Milan 1991.

Michele Gangini,
Tiffany,
leaded glass,
Florence 1990.

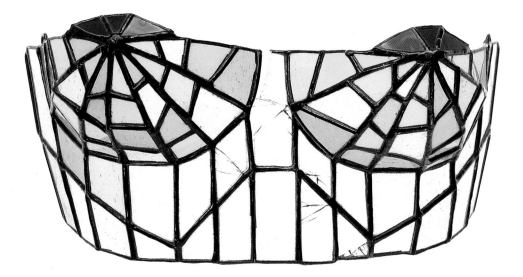

Irene Esposito,
Lego-Seno
(Plugged together),
plastic,
Milan 1991

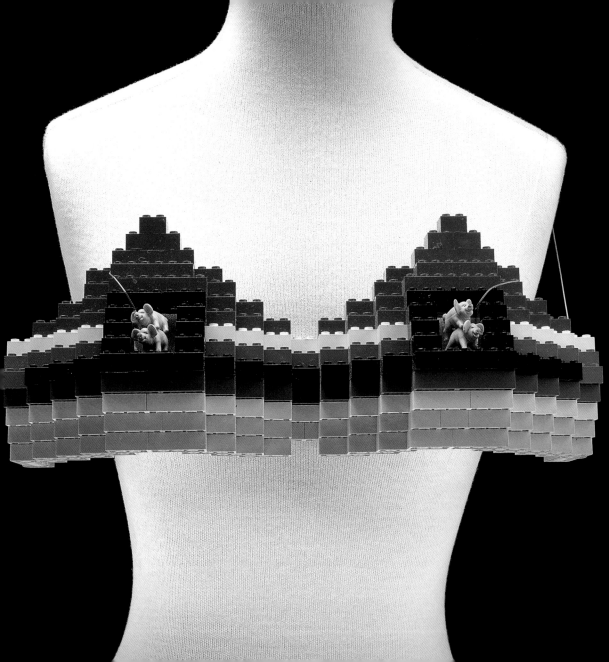

Shaun K. Clarkson,
Sofa-Bra,
furniture upholstery,
London 1991.

Beatrice Banchini,
Ricca
(Independently wealthy),
metal and coins,
Florence 1990.

Isadora Branchizio,
Desdemona,
plastic and material,
Brescia 1990.

Stefano Pillori,
Vedova nera
(Black widow),
cloth and wire,
Florence 1991.

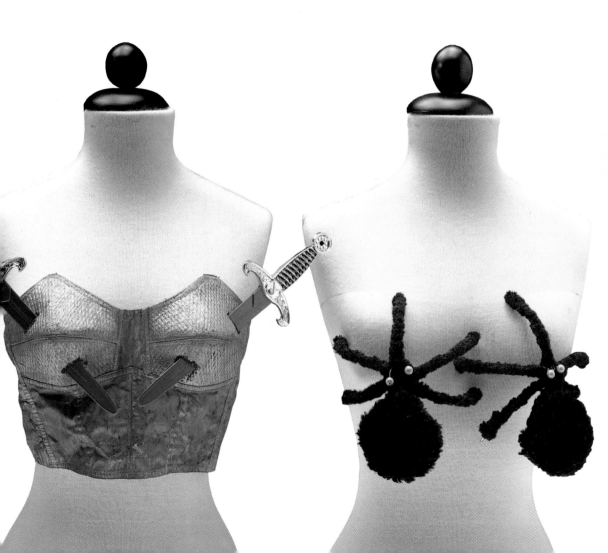

Franco Zeffirelli,
Untitled,
for Maria Callas in *Aida* at
La Scala,
brass and stones,
Milan 1963.

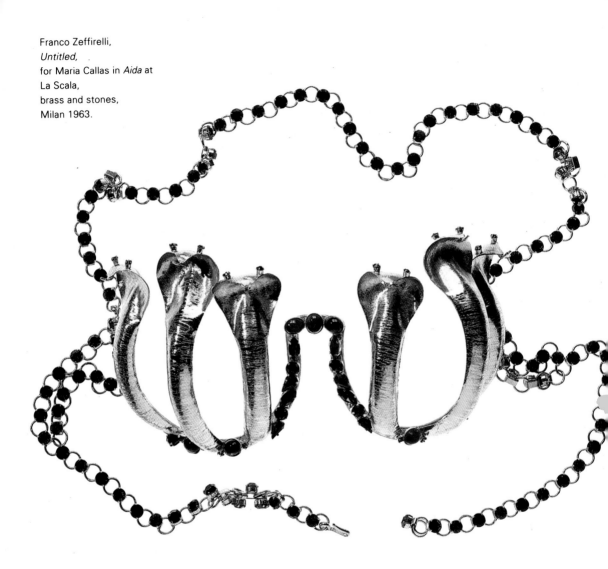

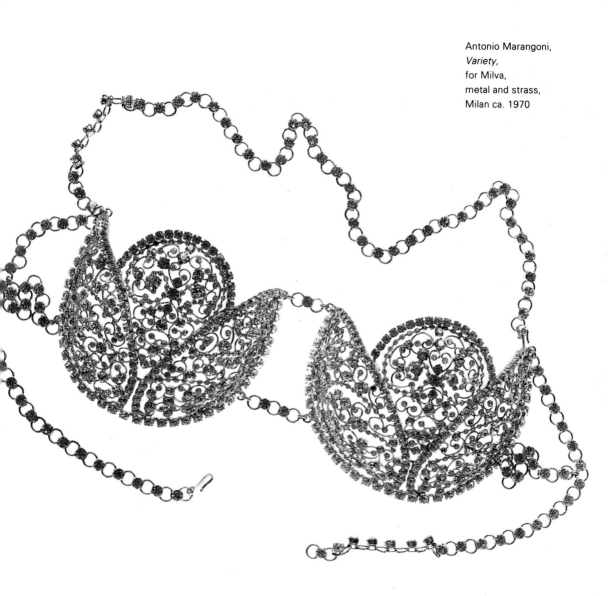

Antonio Marangoni,
Variety,
for Milva,
metal and strass,
Milan ca. 1970

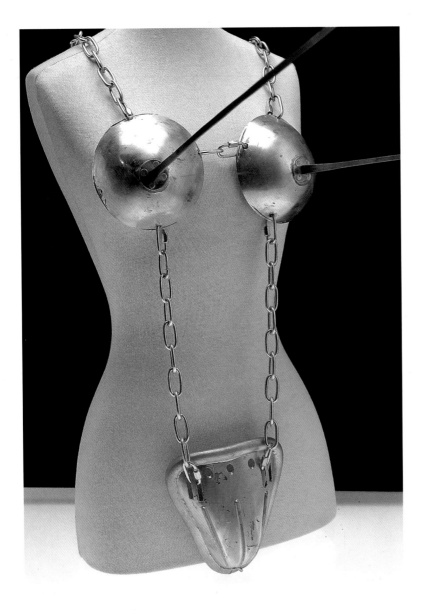

Karim Belhassine,
L'Art-Mature
(Art-mature),
chain and foil,
Paris 1992.

Nicola Falcone,
Casto e Puro
(Chaste and pure),
metal,
Matera 1992.

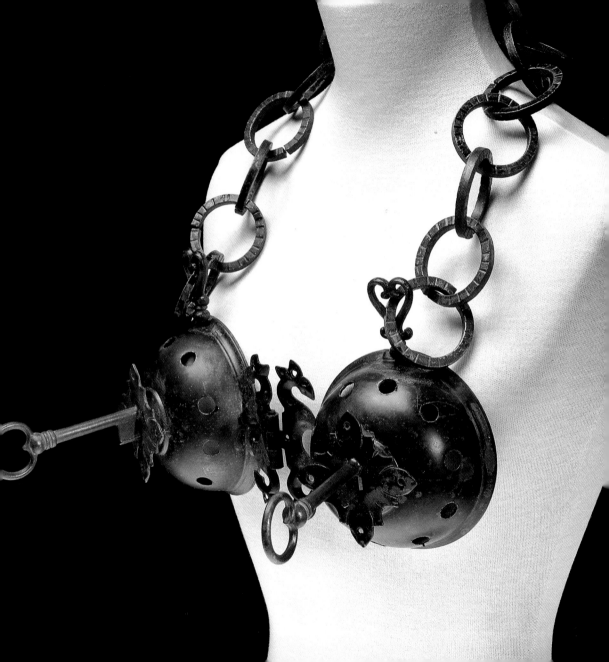

Sergio Binaglia,
Untitled,
for Luisa Veronica
Ciccone,
ceramic and girdle,
Perugia 1990.

Debbie Harter,
Deb-Bra,
hand-made cloth,
London 1991.

Alida Scarnà,
Passeggiata
(Out for a walk),
papier-mâché,
Caltanissetta 1991.

FOLLOWING PAGE:
Silvia Bruschini,
L'ossessione di David
(David's obsession),
velvet and plaster,
Rome 1990.

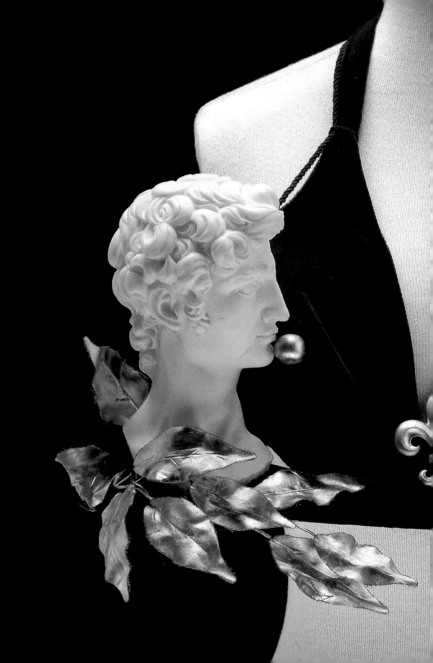

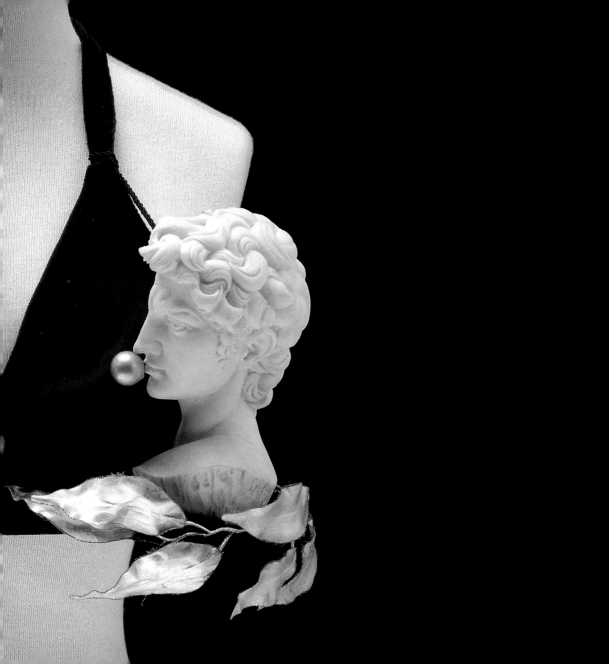

Licia Dotti,
Reggi-Pope
(Pope bra),
plastic,
Rome 1991.

Maurizio Favetta,
Immagina
(Imagine),
"snowballs" and bra
Milan 1991.

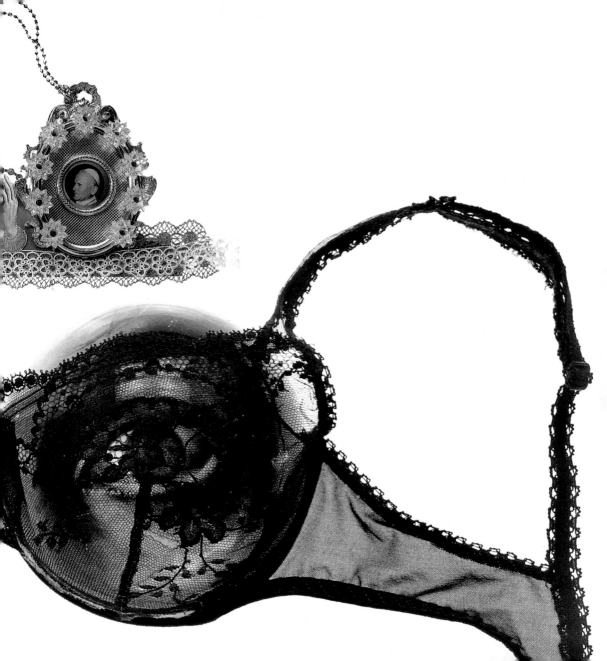

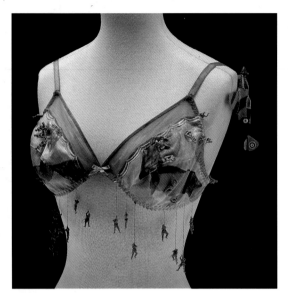

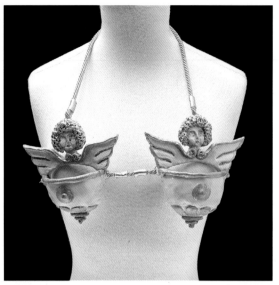

Paolo Mattioni,
Guerra aperta
(All-out war),
material,
Florence 1991.

Vincenzo Lauriola,
In nomine Patri
(In the name of the
Father),
ceramic,
Florence 1992.

Anna Siccardi,
Antiproiettile
(Bulletproof),
bullet-proof material,
Biella 1990.

Micaela Naldini,
Antistupro
(Defensive bra),
pins and material,
Florence 1992.

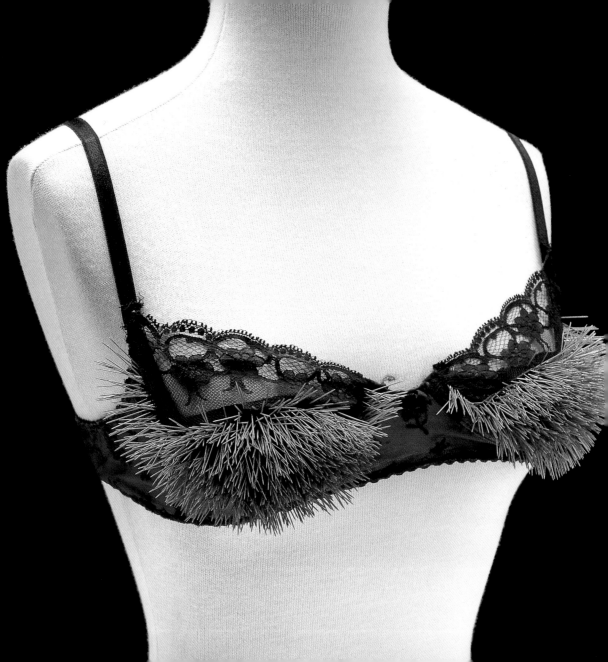

Alberto Coppini,
Abbraccio
(Embrace),
wrought iron,
Florence 1991.

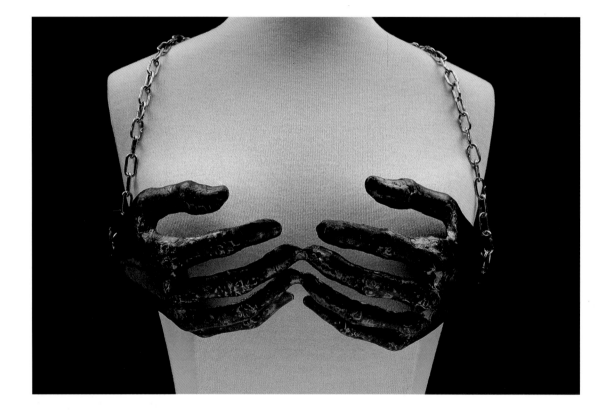

Elio Ferraro,
Schiavo d'amore
(Slave to love),
metal and rubber,
Trapani 1992.

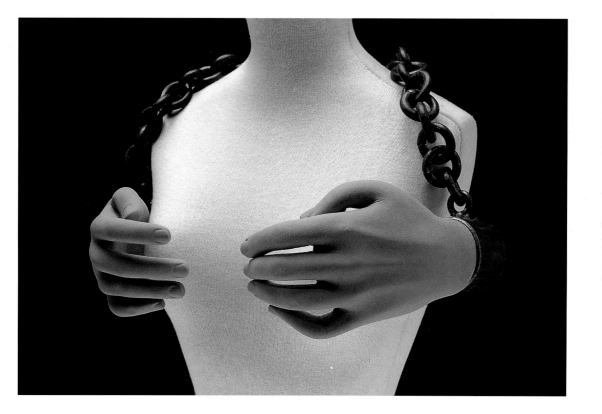

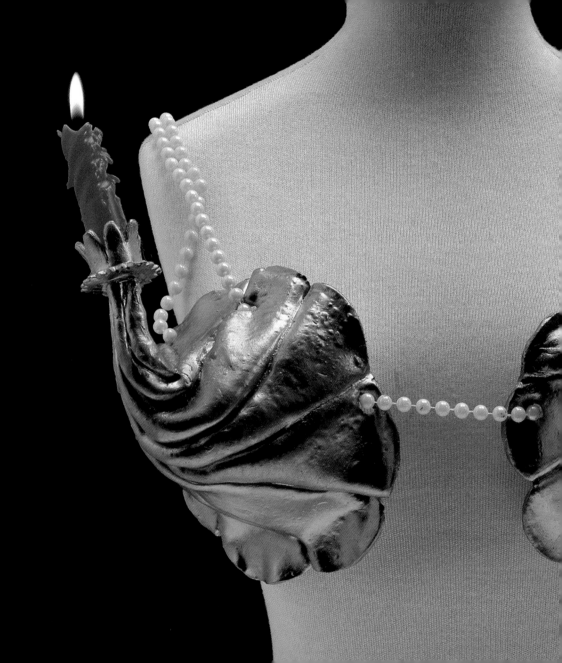

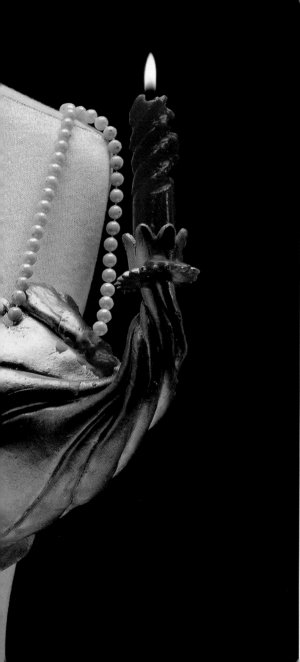

Lillo Milici,
Notturno
(Nocturne),
plasticine, pearls and
candles,
Agrigento 1992.

Lucia Ercolino,
Justine,
cloth and paper,
Florence 1992.

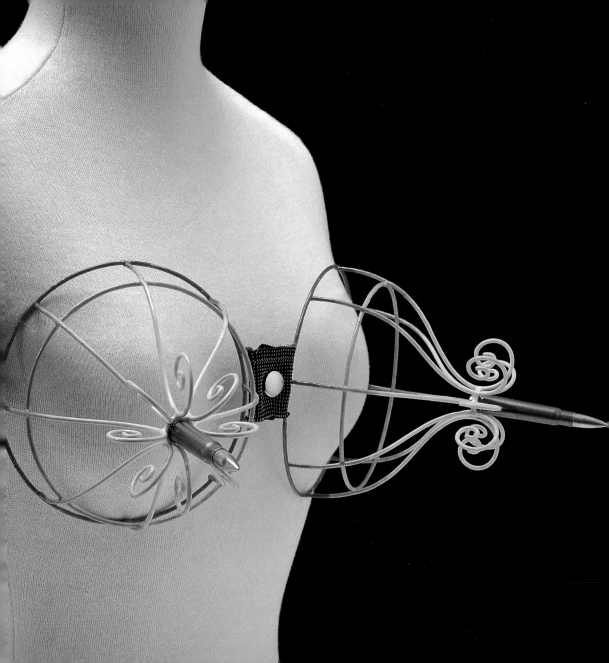

Francesco Mancini,
Preso di mira
(Ready, aim, . . .),
wire and bullets,
Bari 1992.

Monica Schifano,
Silicon Valley,
plastic and cloth,
Rome 1992.

Rosy Meli,
Acqua
(Water),
pearls on cloth,
Latina 1990.

FOLLOWING PAGE:
Andrea Splisgar,
Reggi o' seno
(Well wired),
silver,
Berlin 1990.

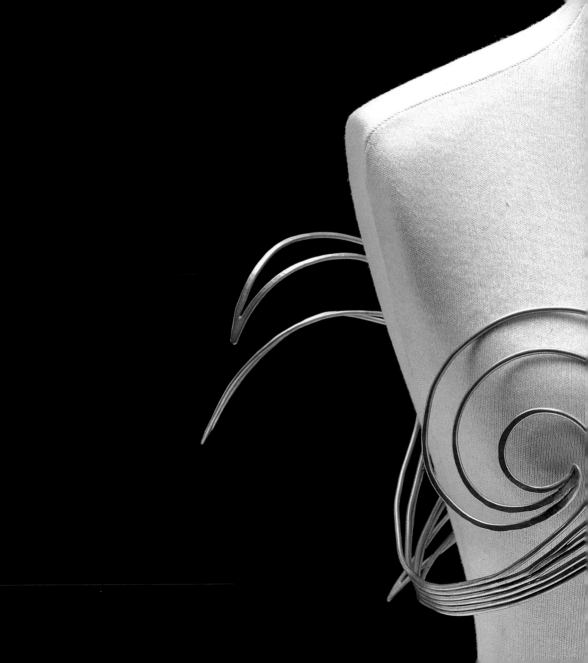

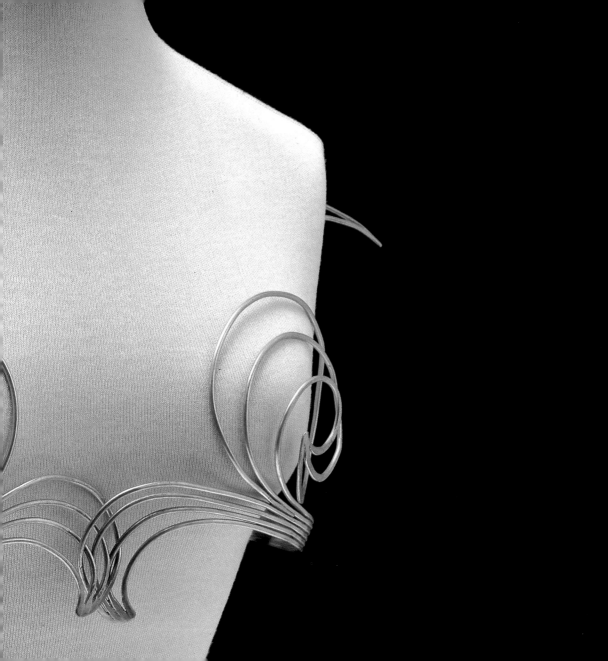

Pinacoseno
(THE PICTURE GALLERY OF THE BRA)

Oil on canvas, tempera on paper, mixed techniques—a variegated and multi-colored gallery of pictorial brassieres. Cups become pretexts for exercises in style, for graphic digressions, for chromatic explosions on a theme, capable of giving free rein to any fantasy. They are brimming with suggestions of every taste: sweet and sour, delicate and provocative.

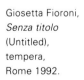

Giosetta Fioroni,
Senza titolo
(Untitled),
tempera,
Rome 1992.

Luigi Falai,
Night and Day,
oil,
Florence 1991.

Marco Lituani,
L'altra faccia dell'amore
(Love's other face),
tempera,
Florence 1992.

154

Paolina Humeres,
Il vento delle tue emozioni
(The wind of your emotions),
oil and metal,
Chile 1991.

Andrea Natrella,
Io ti salverò
(I'll save you),
tempera,
Florence 1991.

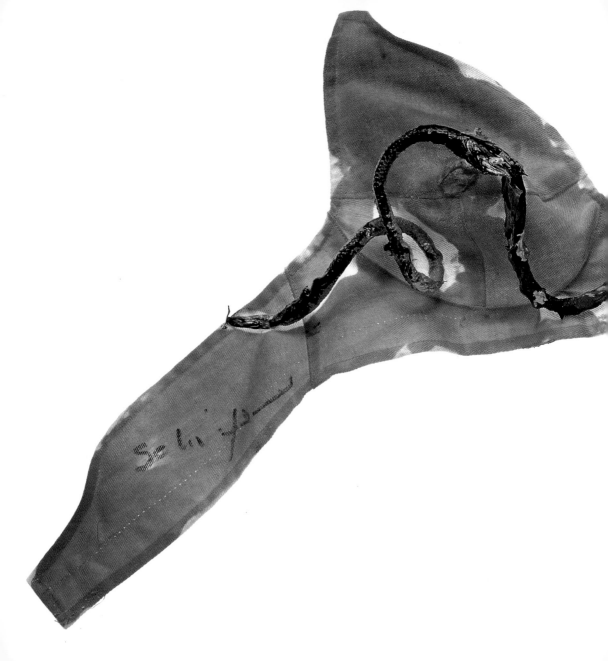

Mario Schifano,
Serpe in seno
(Viper in the bosom),
oil and cord,
Rome 1992.

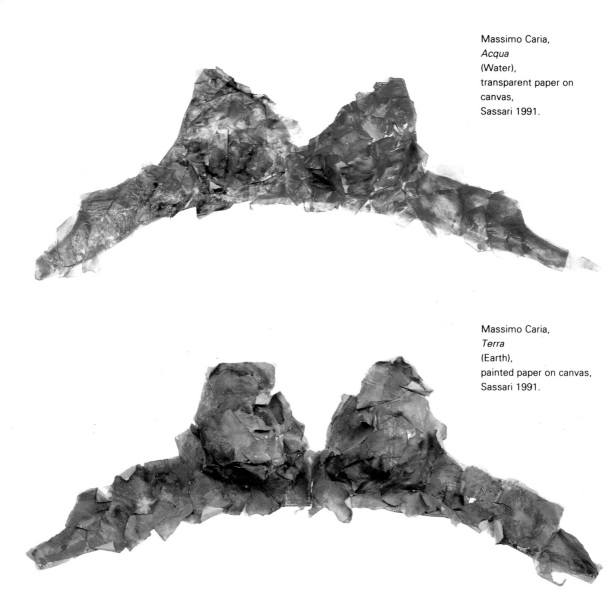

Massimo Caria,
Acqua
(Water),
transparent paper on
canvas,
Sassari 1991.

Massimo Caria,
Terra
(Earth),
painted paper on canvas,
Sassari 1991.

Massimo Caria,
Fuoco
(Fire),
transparent paper on
canvas,
Sassari 1991.

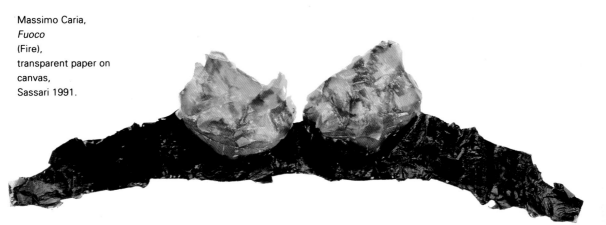

Massimo Caria,
Aria
(Air),
cotton wool on canvas,
Sassari 1991.

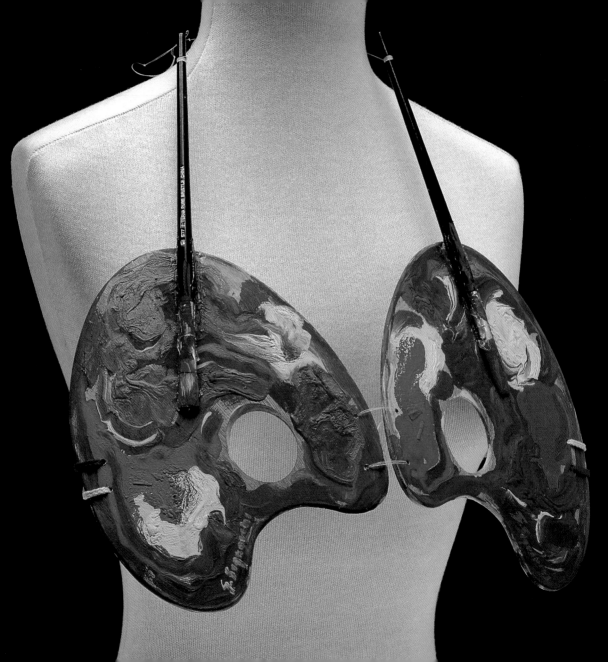

Giuliana Signorini,
Reggi-Tavolozze
(Bra palette),
wood,
Florence 1992.

Yelitza Altamirano Valle,
Azteco
(Aztec),
oil and metal,
Lima 1992.

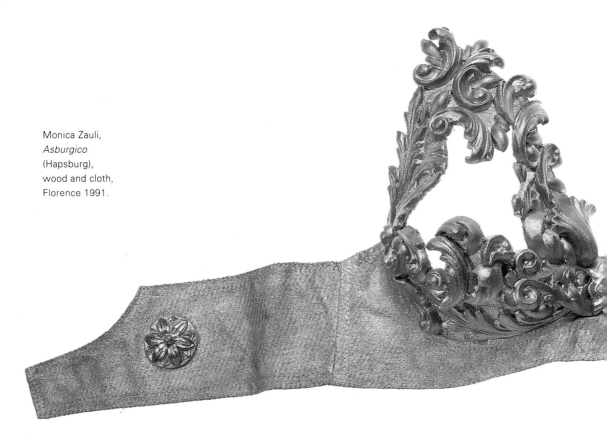

Monica Zauli,
Asburgico
(Hapsburg),
wood and cloth,
Florence 1991.

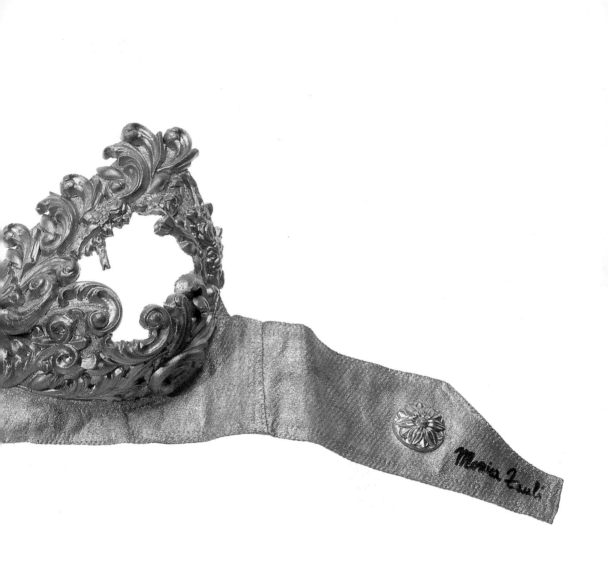

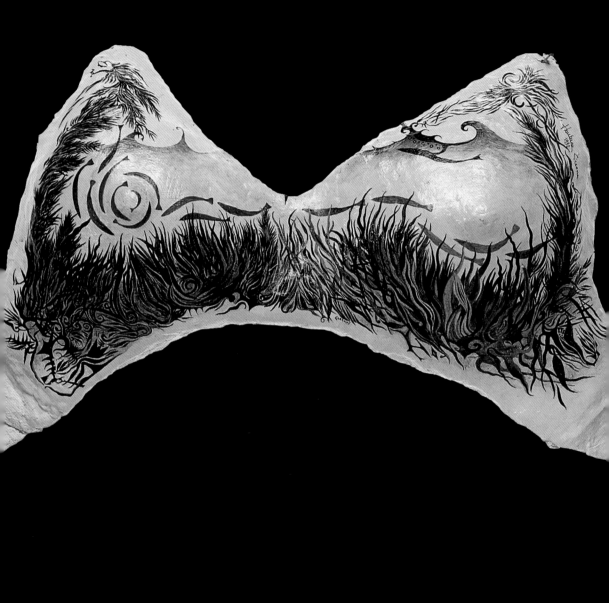

Gianluca Ciccone,
Atlantide
(Atlantis),
plaster, oil and cloth,
Foggia 1992.

Paolo Staccioli,
Cavalli a dondolo
(Hobby horses),
tempera,
Florence 1990.

Antonio Cagianelli,
Turquoise,
acrylic,
Pisa 1992.

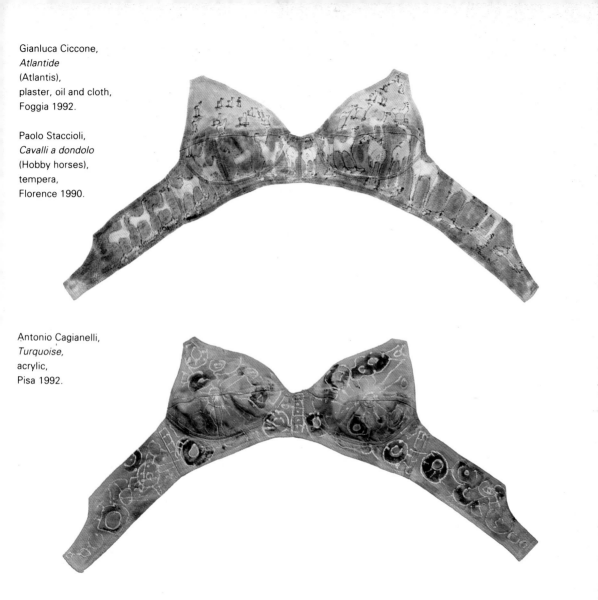

165

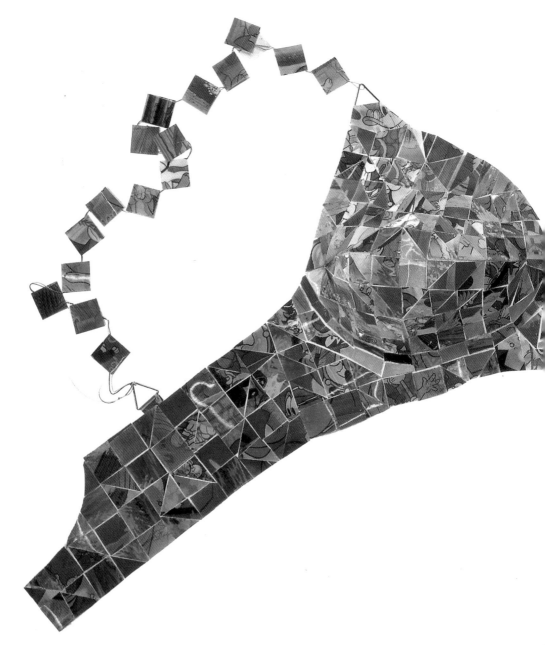

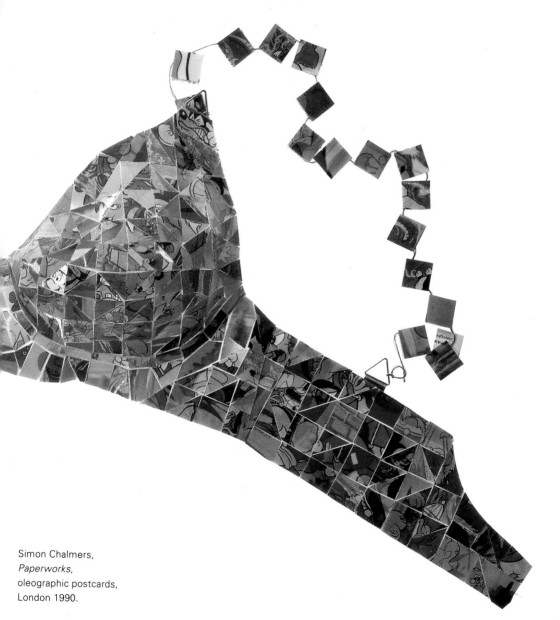

Simon Chalmers,
Paperworks,
oleographic postcards,
London 1990.

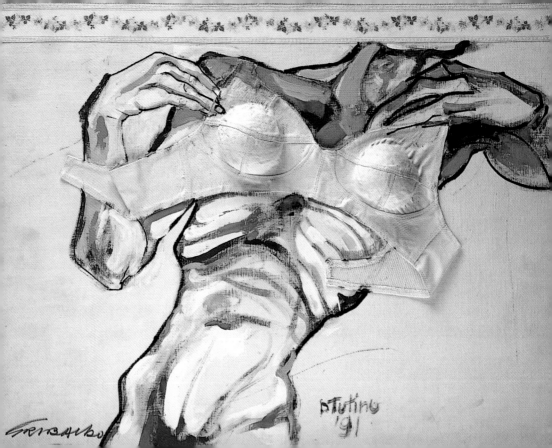

Ezio Gribaudo and
Barbara Tutino,
Allo specchio
(In the mirror),
tempera,
Turin 1991.

Antonia Fontana,
L'aurora e la notte
(Dawn and night),
treated plastic on canvas,
Florence 1991.

Anna Di Volo,
Preziose protubere
(Precious),
tempera and paint,
Florence 1991.

Alfio Rapisardi,
Insieme
(Together),
tempera,
Florence 1990.

169

Sergio Scatizzi,
Antico gioco della palla
(The old ball game),
tempera,
Florence 1992.

Luca Alinari,
Stuzzicanervetti
(Provocative stuff),
tempera and pencil,
Florence 1990.

Vaurence Crevel,
Lunettes lunaires
(Moon glasses),
plaster and cardboard,
Paris 1992.

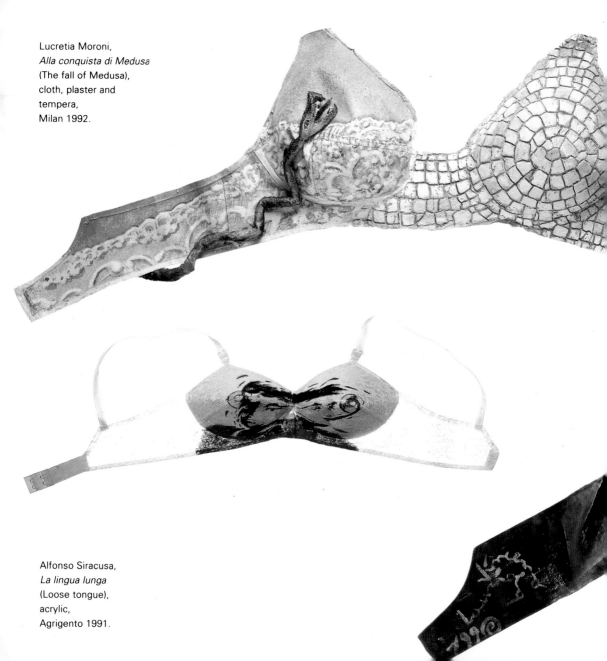

Lucretia Moroni,
Alla conquista di Medusa
(The fall of Medusa),
cloth, plaster and
tempera,
Milan 1992.

Alfonso Siracusa,
La lingua lunga
(Loose tongue),
acrylic,
Agrigento 1991.

Francisco Merello,
Universale
(Universal),
oil,
Chile 1992.

Vincenzo Lauriola,
Maledetto seno
(Damnation bra),
oil,
Florence 1991.

Anna Ferrucci
Levante
(Far East),
tempera and porcelain,
Florence 1990.

Licia Dotti,
Reggi-Immacolato
(Immaculate suspension),
tempera and paper,
Rome 1991.

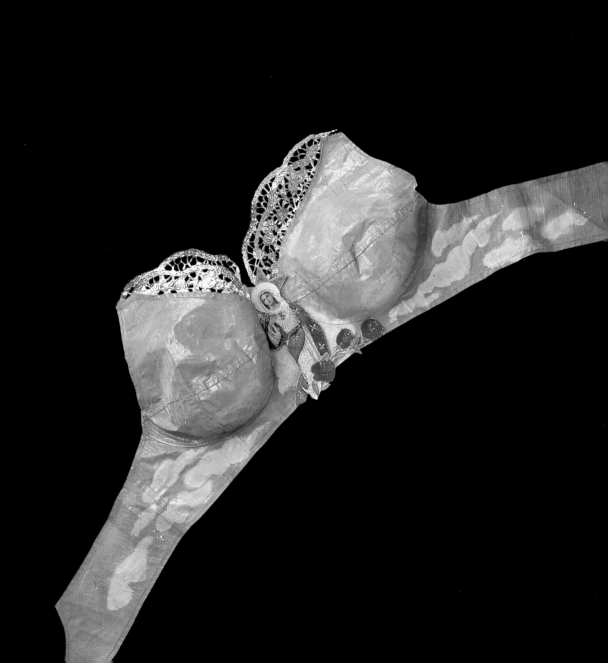

Gabriele Pezzini,
Eyes,
tempera,.
Florence 1990.

Beate Lennarth,
Ideale
(Ideal),
tempera,
Düsseldorf 1992.

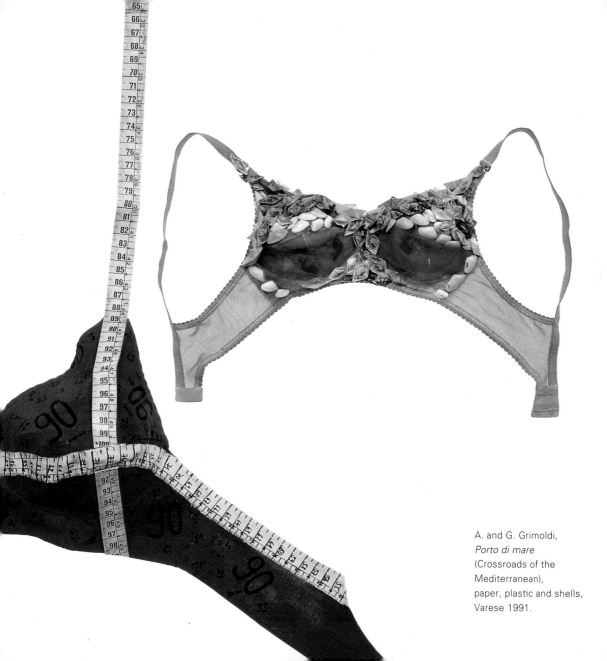

A. and G. Grimoldi,
Porto di mare
(Crossroads of the
Mediterranean),
paper, plastic and shells,
Varese 1991.

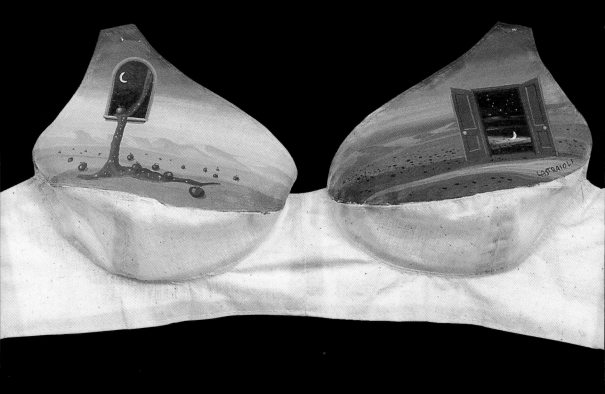

Franco Lastraioli,
Surreale
(Surreal),
tempera,
Florence 1990.

Francisco Smythe,
Colline in fiore
(Hills in bloom),
tempera,
Chile 1991.

179

Michelangelo Prencipe,
Genuina specularità
(True mirror image),
tempera,
Milan 1991.

Silvia Martins,
Orvik-Bra,
sand, tempera and glitter,
New York 1991.

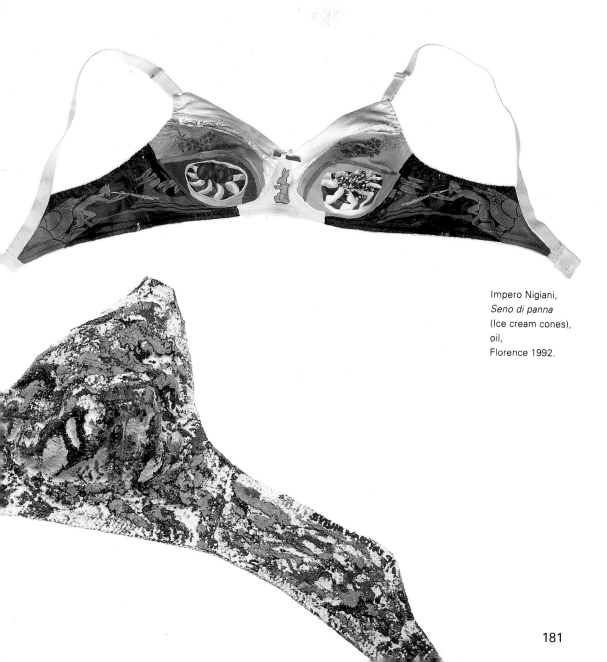

Impero Nigiani,
Seno di panna
(Ice cream cones),
oil,
Florence 1992.

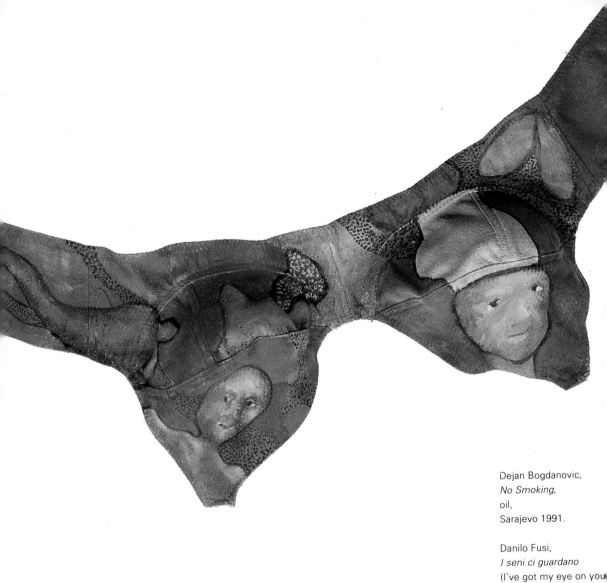

Dejan Bogdanovic,
No Smoking,
oil,
Sarajevo 1991.

Danilo Fusi,
I seni ci guardano
(I've got my eye on you)
pencil,
Florence 1991.

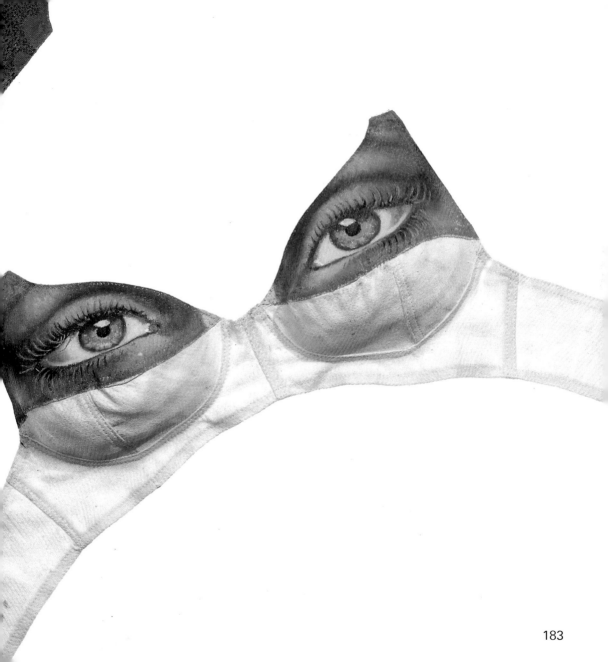

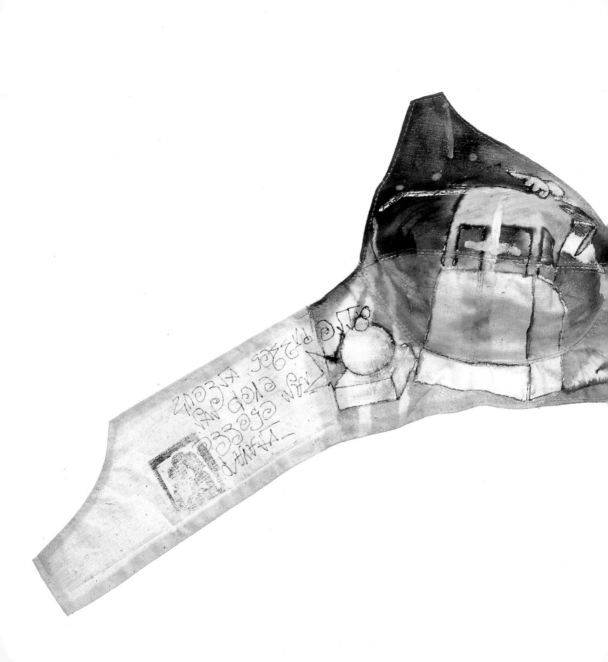

Luca Marietti,
Due bufali blu
(Two blue buffaloes),
tempera,
Florence 1990.

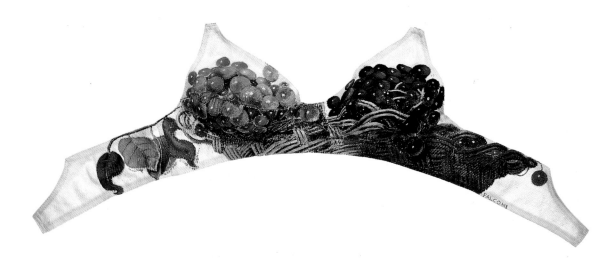

Walter Falconi,
Natura morta
(Still life),
oil,
Florence 1991.

Samuele Mazza,
Le due potenze
(Superpowers),
tempera,
Florence 1991.

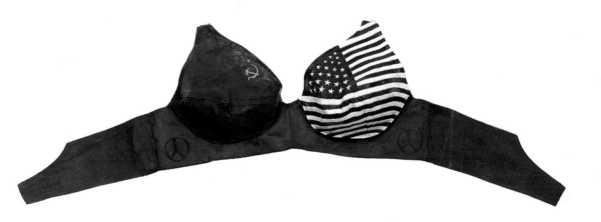

Translator's Note

There may be something harder to translate than a pun, but in nearly twenty years of professional translating I've never come across it. Which may explain why the anonymous translator(s) of the main text of *Brahaus* left the titles untouched. It certainly accounts for why my own title translations sometimes look so little like the originals.

Like the works they designate, the titles are often multi-layered and playful. They draw on brand names, names of TV programs, slang — all kinds of inside references. Many times it makes more sense to translate what's being suggested beneath the text, rather than the text itself. For example: "Seno di panna" means, more or less literally, "breasts white as cream," but also fools around with the name of a familiar

drumstick-like ice cream treat, "Cuor di Panna," depicted on the bra. "Ice cream cones" seemed to me to be the closest translation.

Or take "Porto di mare" — literally, "a seaport" — but also a common way of referring to a place frequented by a constant stream of visitors. In other words, a lady whose bosom is a "porto di mare" is no lady: "Crossroads of the Mediterranean" comes closer to the idea.

I'd like to thank Alessandra, Giorgio, Emilio, Sacha, Barbara, and Susan for their help and humor. I hope the translated titles are as much fun for the reader as working with the originals was for me.

Joe McClinton